PRE-PRESS

First published in the United States of America by
Rockport Publishers, Inc.
33 Commercial Street
Gloucester, Massachusetts 01930-5089
Telephone: (978) 282-9590
Facsimile: (978) 283-2742
www.rockpub.com

ISBN 1-56496-664-X

10 9 8 7 6 5 4 3 2 1

Design: Stoltze Design

Printed in China.

graphicIDEA
resource

PRE-PRESS

Building Innovative Design Through Creative Pre-Press Techniques

Constance Sidles

PRE-PRESS

Prepress

We production managers hate surprises. We get too many of them when we go on press. "You mean you don't want that drop cap on the last page to be cyan when all the other drop caps in the brochure are lavender?" a pressman will ask, his eyes wide with surprise. Or "Why did that oxblood-leather coat come out looking like the ox died?" the art director wants to know when he sees the first signatures. Or, my all-time favorite, "That layout looked fine on my monitor—why couldn't you print it right?" asks the designer, fixing me with a look that would melt the Wicked Witch of the West.

You can see why we hate to go to press okays. That's when the ink hits the paper and, all of sudden, we notice things popping out at us like the Mummy chasing Abbott and Costello through the tomb chamber. He's hard to miss. Why didn't we see him in pre-press?

Part of the reason is because paper and presswork introduce variables that make printing more an art form than a science, for all that printers brag about Total Quality Management and Statistical Process Control. That does not mean, however, that translating your designs from monitor to printed page is guesswork. On the contrary, the more you know about the limits and potential of the process, the more you can push your designs to those extremes that will catch the eyes and hearts of your readers.

Doris is a perfect example. She is the art director for a large catalog company based in Seattle. Doris loves to create designs that challenge the printing process—they're the kind of layouts that are almost impossible to print. Almost.

One month, she designed a series of screen tints that were so subtle, they verged on the invisible. When I got them on press, the colors were all wrong. "This tint should be pale beige and instead it's green," I said, showing the color proof to the printer.

He hauled out his loupe and looked at the signature that had just come off the press. "Well, there's your problem," he said. "The magenta dots aren't printing at all."

I leaned over and looked. No magenta dots. "So are you going to remake the plates?" I asked.

"Oh no, those dots are too small to print."

"Do you mean to tell me that your press is incapable of printing dots that appear in the film?" I asked. I wasn't trying to be confrontational—I sincerely wanted to know.

"Uh, I'll get the plate man over here," the printer said, picking up the phone.

In short order, the plate man came running up, loupe in hand. He peered at the offending layout. Then he, too, began to explain about the dots. "You see, ma'am, dots get more extreme when you get them on press. The dark ones get darker and the light ones get lighter. If you start out with dots too small, they just disappear."

"Are you telling me that I have to go back to my art director and tell her she can't design tints like this because you can't print them?" I asked. Doris should know about this, I was thinking, so she doesn't make that mistake again.

The plate man looked at me for a second. Then, "Stop the presses," he said. "We will remake the plates."

Two hours later, Doris got her pale beige tints. She knew how far she could push the press, and that's exactly how far she went.

If you find yourself encountering too many examples of designs that don't print correctly, then this book is for you. It's filled with tips and tricks that will tame the Monster and give you what you want: beautiful designs printed on the page - just as you envisioned.

THE AMENITIES ARE
BEYOND IMAGINATION.

THE ACCOMMODATIONS
ARE BEYOND EXPECTATION.

EVERYTHING ABOUT THIS PLACE
IS BEYOND CONVENTION.

AND
SO ARE THE
Piña
coladas.

Beyond the perfect weather. Beyond the world-class shopping, sun-sports, trendy bistros and high-energy night life. Beyond extensive facilities, a wide range of refurbished properties, and 1,000 new hotel rooms by 1999. Even beyond our miles and miles of beautiful beaches. Call our Convention Sales Department at 1-800-933-8448 or e-mail services@miamiandbeaches.com for your free Meeting Planner Guide and send your next group off to a place that's BEYOND CONVENTION. http://www.miamiandbeaches.com

Client *Tropical Miami*
Design *Turkel Schwartz & Partners*

When selecting originals, pay attention to the three most important technical fundamentals of photography: sharpness, color, and range of tone. This photo has pinpoint detail, balanced and bright colors, and a full range of tones from deepest shadow to brightest highlight.

REDUCTION OF QUALITY

Client	*le toolpub magazine,*
	produced by Yoichi Nakamuta at E & Y Gallery
Design	*Fly*
Designers	*Fabian Monheim, Sophia Wood*
Art Directors	*Fabian Monheim, Sophia Wood*
Photographers	*Christophe Husson, Joe Magrean, Horst Dietkerdes, Lomo, Simone White, Fabian Monheim*
Copywriters	*Simone White, Sophia Wood, Graham Wood*

Printing presses do not improve photos. They make details more fuzzy, throw colors out of whack, and compress the number of tones. Here, the original photo was in focus; but once on press, details in the fur became lost. The whites have gained in magenta and yellow, and contrast has been increased, with a corresponding loss of midtones. The design works only because these printing tendencies serve to focus attention on the dogs' expressions.

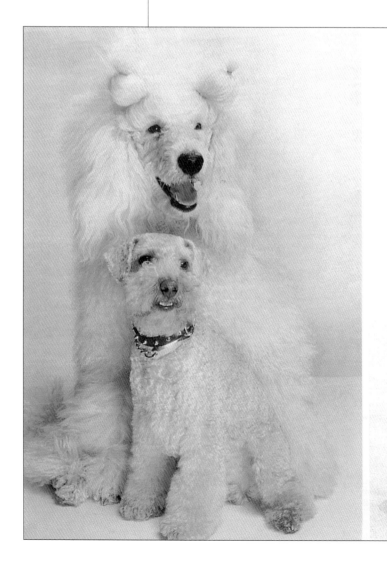

paris!
spéciale

nous commençons tous! alors toujours, le tool pub est fancy! all together now! all you need is love! be here now! je t'aime! sûr la pont d'avignon! london now meets paris tomorrow and tokyo again!

it's springtime for cross cultural design relations — and all the things to see are lovely, and clever. that's why it's a pub, but one that's fancy. how often does cleverness combine with fun to make something that's great? as often as it can, and it does right here. like duck with orange, or sacha with distel. everything is prix fixe! and japanese! sacha (as in distel) sounds a bit like sushi, and so does serge! it's a three way exchange — a little bit unexpected, a little bit cool, a little bit romantic; just like paris itself! i'm sold on the idea — ooh la la!

what about the fjords? how do they fit in? like a floating fairy in the bubble or a carrot in the corner. vision precedes actuality. i should mention dogs. if 'at' is where you have to be, paris is where you'll find it!

Peace I leave
with you.
My peace I
give you.
I do not give
to you as the
world gives.
Do not let
your hearts be
troubled
and do not be
afraid.

J o h n 1 4 : 2 7

DEPTH OF FIELD

Client	*Spring Hollow*
Design	*Held Diedrich*
Art Director	*Doug Diedrich*
Designer	*Megan Snow*

Sharpness is more than focus – it's also depth of field.
Depth of field refers to the amount of distance in which
objects are sharp from the front of the photo to the
back. This photo is in sharp focus, but has poor depth
of field. The blossoms at the top are blurred, and
the distant background is completely out of focus. Be
careful when you use photos such as this. Blurriness
can be extremely distracting to readers. Fortunately,
here the colors are vivid and distinct enough to create
the feeling of an abstract.

BLURRY FRAMES

Client	*La Prairie*
Art Director	*Ched Vackorich*
Designer	*Ched Vackorich*
Manufacturer	*S. Posner Sons Inc.*

Sometimes a blurred background serves to draw the reader's eye to the central portion of the photo. Note here how the out-of-focus apricots (photo on top row, second from left) frame the sharp kumquats in the center of the picture. Intelligent cropping has kept the kumquats from being overwhelmed by the sheer weight of the larger, heavier fruit in the foreground.

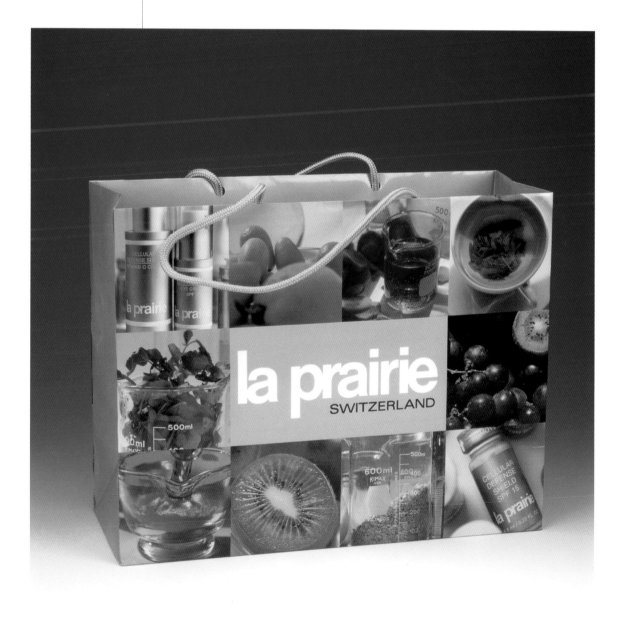

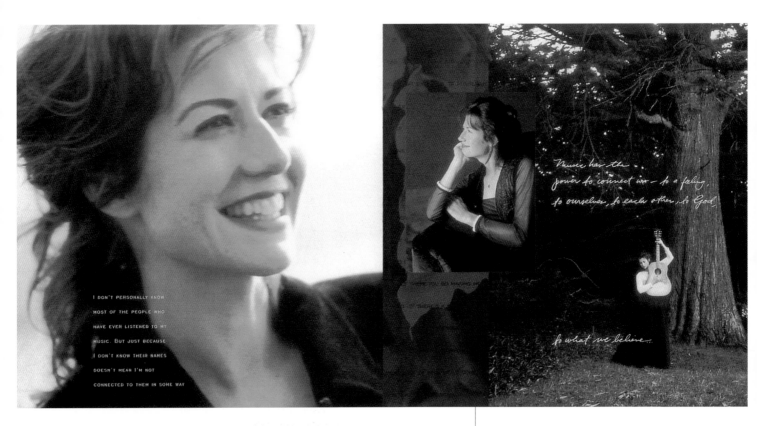

I DON'T PERSONALLY KNOW
MOST OF THE PEOPLE WHO
HAVE EVER LISTENED TO MY
MUSIC. BUT JUST BECAUSE
I DON'T KNOW THEIR NAMES
DOESN'T MEAN I'M NOT
CONNECTED TO THEM IN SOME WAY

TECHNICAL CONTRIBUTIONS TO MOOD

Client | *Amy Grant Productions/Blanton Harrell Entertainment*
Design | *Anderson Thomas Design Inc.*
Art Director | *Susan Browne*
Designer | *Susan Browne*
Illustrator | *Kristi Carter (hand-lettering)*
Photographers | *Kurt Markus, Just Loomis*
Copywriter | *Amy Grant*

Blurry photos create the feeling of motion, informality, or nostalgia. Notice the different moods created in the top spread by the two portraits in focus versus the one out of focus. To maximize the snapshot quality of the photo on the top left, a designer might separate the photo at a coarser screen value (133-line screen rather than 150, for example). Enlarging such a photo more than 1,000 percent increases the graininess, adding to the blurred feeling.

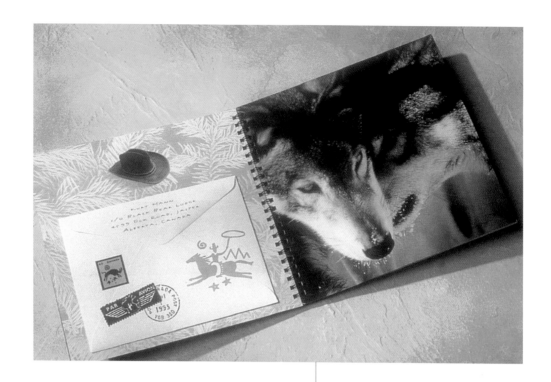

UNSHARP MASKING

Client	*Rare Indigo*
Design	*HerRainco Design Associates Inc.*
Art Director	*Casey Hrynkow*
Designer	*Deb Kieselbach*
Photographer	*John Sherlock Photography*

Unsharp masking during scanning can increase the apparent focus of a photo. Unsharp masking is an electronic technique that maximizes the differences between tones within a photo. In effect, tonal differences are "stepped" out from each other. The amount of unsharp masking can be varied. A little unsharp masking would bring out the individual hairs on these wolves' faces and make one face stand out from the other. A lot of unsharp masking would make each hair look like a line drawing.

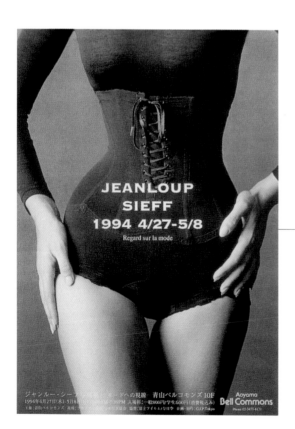

TONAL RANGE

Client	*Aoyama Bell Commons*
Design	*Nomade, Inc.*
Designer	*Toshio Shiratani*
Creative Director	*G.I.P. Tokyo*
Photographer	*Jeanloup Sieff*

Exposure determines the range of tones present in a photo. Ideally, a photo should have some detail in all but the darkest shadows, good representation of the midtones, and at least a pin dot structure in the brightest highlights. This photo is perfectly exposed, with bright whites, deep shadows, almost continuous grayscale midtones, and detail everywhere.

OVEREXPOSED PHOTOS

Client	*Big Magazine*
Design	*Madoka Iwabuchi*
Photographer	*Hiromix*

Overexposed photos lack detail in the highlight areas, and even midtones can be flat. You can try to increase highlight detail while scanning or color-correcting on your desktop, but bear in mind that you are asking your separator (or your software) to supply data that isn't in the original. In my experience, working with overexposed photos is a waste of time, unless you want an edgy look, as in this example.

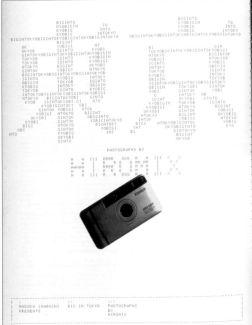

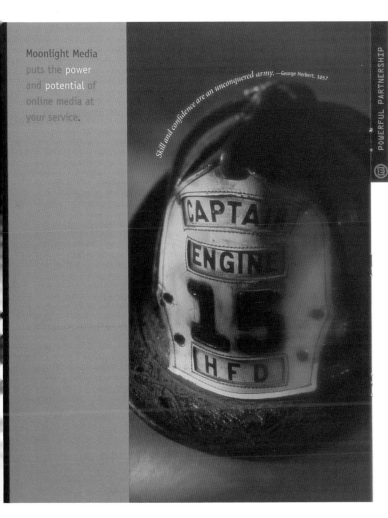

Moonlight Media puts the power and potential of online media at your service.

Skill and confidence are an unconquered army. —George Herbert, 1657

Our experienced, imaginative staff is ready to serve as your technology partner, helping you achieve your business goals with speed and efficiency. And Moonlight Media's commitment to you is ongoing. Once we design your Internet or Intranet site, we consult with you on developing

your strategy and targeting your audience. And our technology experts keep you aware of emerging tools and opportunities that will prove valuable to you and the success of your business.

You see, Moonlight Media takes a handcrafted approach to handling your Internet, Intranet, and Web-based needs. And if you think "handcrafted" is an inappropriate term to describe an outfit whose stock in trade is leading-edge online technology, please keep this in mind:

Our company is not about technology. Our company is about using technology to help your company do business more successfully.

James M. Vardaman & Company

For this forestry consulting firm, Moonlight Media developed a web site that provides critical timber market information for investors, along with a private archive of timber publications that may be reviewed by authenticated site members. We also constructed a JAVA-based software tool that allows site visitors to demo the company's PTAEDA2V+ECONVR software that predicts timber yields and their associated financial returns.

Stuart C. Irby Company

Moonlight Media constructed a territory planning and reporting tool for Irby that allows outside salesmen to plan and track their weekly sales activity. Salesmen use custom Active X controls, developed by Moonlight Media, to enter their plans into the parent Call Planner database. Once entered, these plans are tracked and later married to mainframe data to generate performance reports. Managers also have the capability to log on and review the call planning activity.

MOONLIGHT MEDIA, INC.

Because your vision is bigger than a site.

MIDTONE PLUGGING

Client	Moonlight Media, Inc.
Design	Communication Arts Company
Art Director	Hilda Stauss Owen
Designer	Hilda Stauss Owen
Photographer	Photodisc: Design Photo Image
Copywriter	David Adcock

If you're unsure about whether a photo will plug up on press, squint your eyes and look at the midtones in the original. The loss of detail you see when squinting is similar to the amount of plugging the press will produce. Open up the midtones when the original is separated.

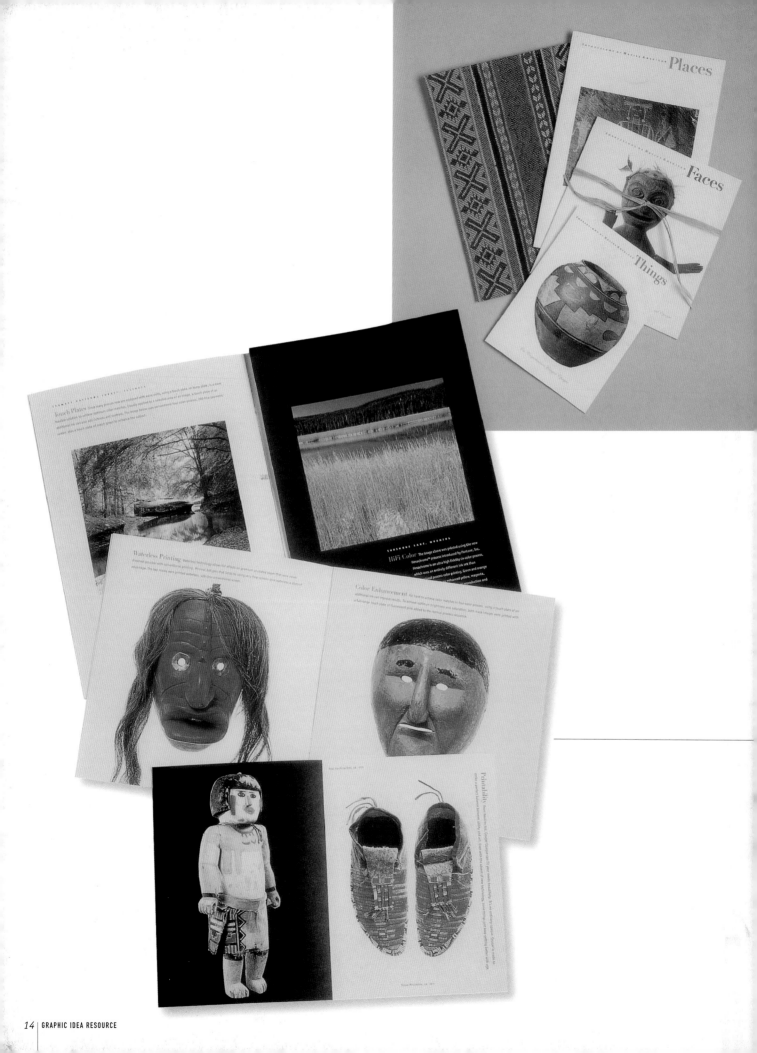

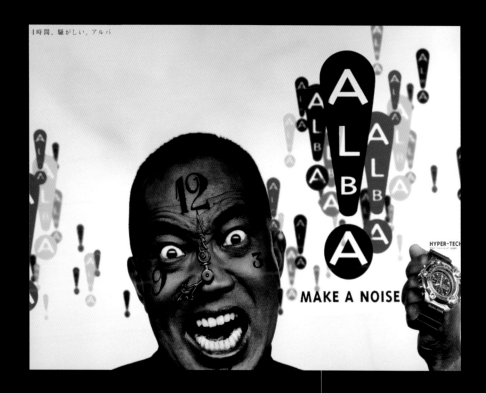

OPENING MIDTONES

Client	*Weyerhaeuser Paper Company*
Design	*Sibley/Peteet Design*
Art Director	*Don Sibley*
Designer	*Don Sibley*

Midtones must be opened up even further if your design prints on uncoated paper. That's because dots gain more on uncoated stock. If you separate normally, bright colors will plug up on press. To achieve the sparkling color you see here on uncoated stock, you should work closely with your printer so your separations are opened up enough to allow for expected dot gain, but not so open that shadows look thin. In addition, proofs of separations which have been opened up look washed out, so you must tell the printer you're expecting to gain back a lot of color saturation on press. This is one of the few times when you don't want the printer to match the proofs.

CONTRAST VS. CONTRASTY

Client	*Seiko Corporation*
Design	*Asatsu, Inc.*
Art Director	*Yoichi Komatsu*
Designer	*Yoichi Komatsu*

Contrast in a photo contributes to detail because tones are delineated clearly. A photo with good contrast is not the same as a contrasty photo. A contrasty photo is one in which deep shadows interact with very light highlights without a lot of midtones in between. A photo with good contrast, on the other hand, is one which has deep shadows and bright highlights, and every midtone in between. You can enhance contrast during scanning. But when you reproduce black and white photography, the best way to increase contrast is to screen two negatives, one that emphasizes the highlight detail and one that emphasizes the deep shadows. You can then print the two screens with different ink colors, such as black and brown, or even black and gray.

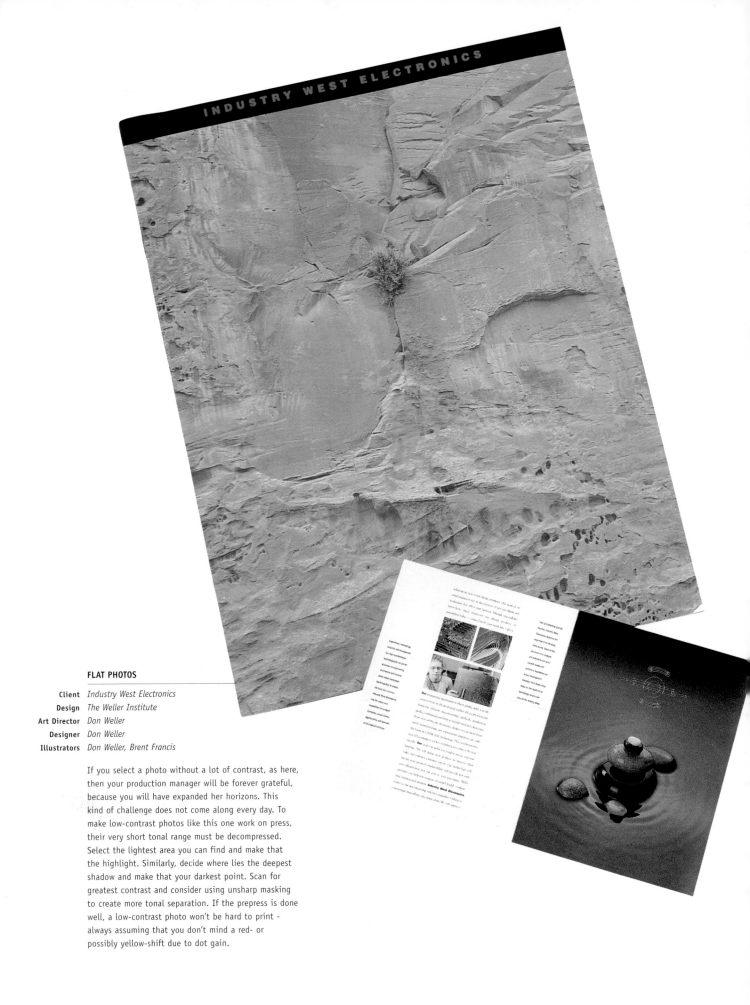

FLAT PHOTOS

Client	Industry West Electronics
Design	The Weller Institute
Art Director	Don Weller
Designer	Don Weller
Illustrators	Don Weller, Brent Francis

If you select a photo without a lot of contrast, as here, then your production manager will be forever grateful, because you will have expanded her horizons. This kind of challenge does not come along every day. To make low-contrast photos like this one work on press, their very short tonal range must be decompressed. Select the lightest area you can find and make that the highlight. Similarly, decide where lies the deepest shadow and make that your darkest point. Scan for greatest contrast and consider using unsharp masking to create more tonal separation. If the prepress is done well, a low-contrast photo won't be hard to print - always assuming that you don't mind a red- or possibly yellow-shift due to dot gain.

SPECULAR HIGHLIGHTS

Client	Deleo Clay Tile Company
Design	Mires Design Inc.
Art Director	Jose A. Serrano
Designer	Jose A. Serrano
Copywriter	Kelly Smothermon

Specular highlights are highlights that reflect light directly back to the camera lens. When you separate photos with specular highlights in them, blow out the highlights completely so they have no dot structure at all. This will expand the tonal range of the photo overall and will also give readers the sense that the subject is shiny. Look at the blue tiles at the bottom of this photo. Why do we know they have been fired with a glossy glaze and the other tiles have not?

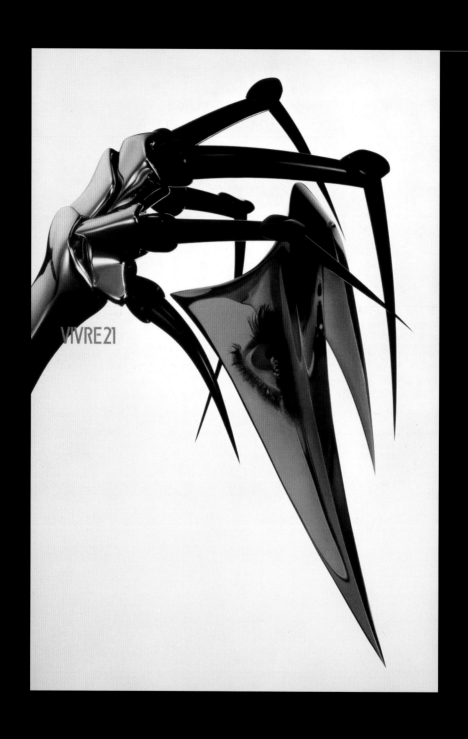

METALLIC SUBJECTS

Client *Vivre 21*
Design *Seiju Toda*
Copywriter *Masayasu Okabe*
Typographer *Masayasu Okabe*
Photographer *Kazumi Kurigami*

Specular highlights can be a major problem when photographing shiny metallic objects. Metals pick up colors from the surrounding background, as well as the light from the photographer's flash and studio lighting. To reproduce metals well, a separation must have three things: a few specular highlights, to indicate the high reflectance of the metallic surface; some vignetted highlights to show contour; and high contrast between deep shadows and intense highlights to make objects glisten. Look at this poster with a loupe and note the different highlights. Some have no dot structure (specular highlights), while some have a vignetted structure, fading away to pin dots. Look especially at the specular highlights that are close to deep shadows—they glisten so much it almost hurts to look at them.

SUBTLE CONTOURING

Client | *East Asia Heller Ltd.*
Design | *Alan Chan Design Company*
Art Director | *Alan Chan*
Designers | *Alan Chan, Jiao Ping*

These metal fish show many large, specular highlights. Usually large, blown-out highlights such as these would make a photo look flat. But notice the contouring present in the gold wire surrounding the fishes' scales. Look closely and you'll see vignetted highlights. The effect is subtle, yet crucial.

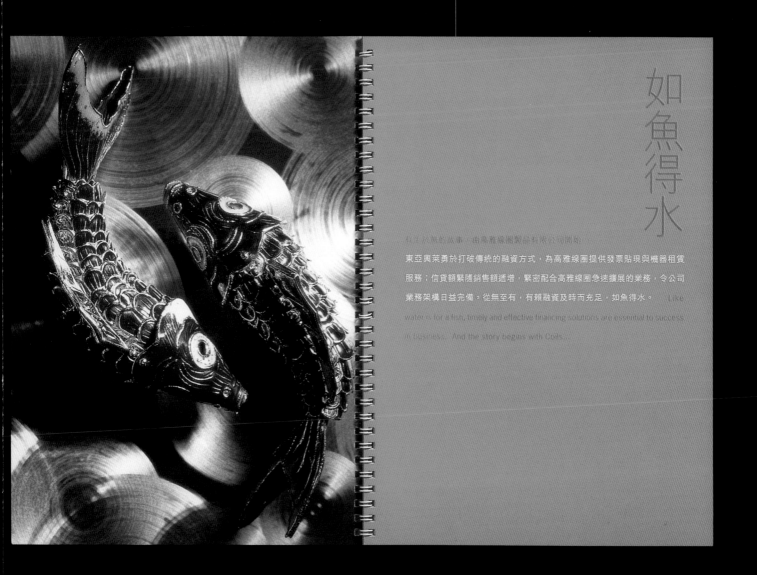

如魚得水

有生於無的故事，由東亞雅線圈製品有限公司開始。

東亞奧萊勇於打破傳統的融資方式，為高雅線圈提供發票貼現與機器租賃服務；信貸額緊隨銷售額遞增，緊密配合高雅線圈急速擴展的業務，令公司業務架構日益完備。從無至有，有賴融資及時而充足，如魚得水。Like water is for a fish, timely and effective financing solutions are essential to success in business. And the story begins with Coils...

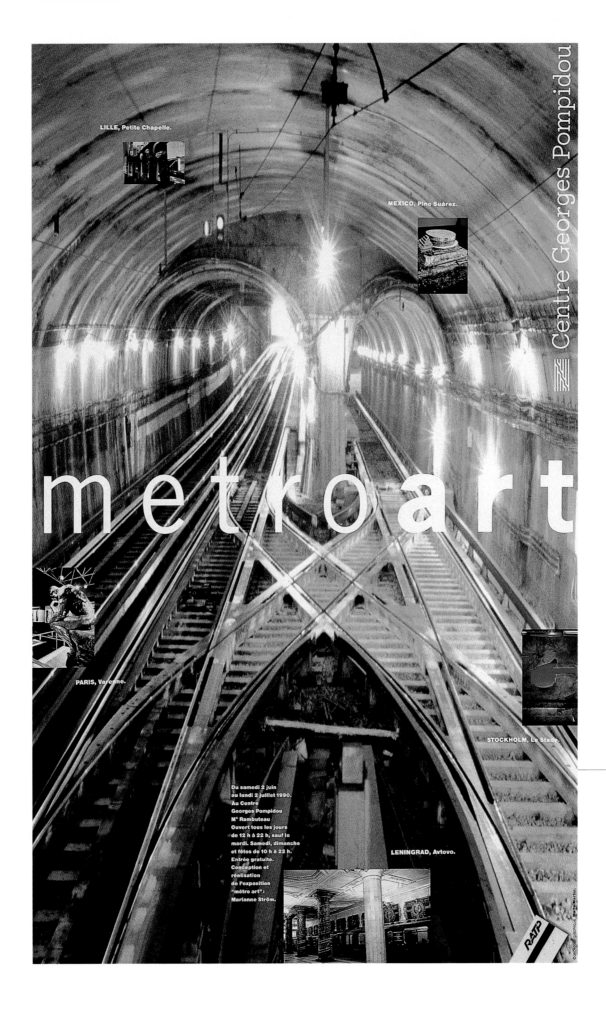

LILLE, Petite Chapelle.

MEXICO, Pino Suárez.

Centre Georges Pompidou

metroart

PARIS, Varenne.

STOCKHOLM, Le Stade.

Du samedi 2 juin
au lundi 2 juillet 1990.
Au Centre
Georges Pompidou
M° Rambuteau
Ouvert tous les jours
de 12 h à 22 h, sauf le
mardi. Samedi, dimanche
et fêtes de 10 h à 22 h.
Entrée gratuite.
Conception et
réalisation
de l'exposition
"métro art":
Marianne Ström.

LENINGRAD, Avtovo.

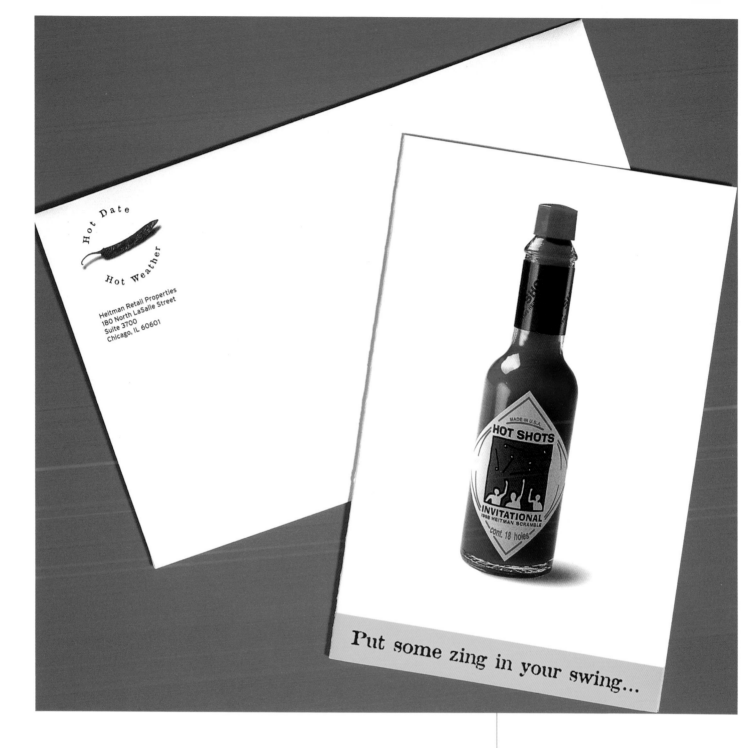

MORE POWERFUL THAN A LOCOMOTIVE

Client *Centre Georges Pompidou*
Design *Malte Martin Atelier Graphique*
Designer *Malte Martin*

Production managers love challenges like this - they are what give us our optimistic dispositions. Here, we have specular highlights in the rails, blown-out light sources in the sconces, nonreflective wood and walls, and everything colored gold and brown. How is the reader to tell the metal apart from the wood and walls? Contrast and shape determine the metallic gleams. Look at the round highlights in the rails on the far left. They reflect the sconces on the wall, as only metal could. The wooden ties do not behave the same way. Now study the rails in the center. Large areas of blown-out white contrast with color, telling our eyes these, too, are metal.

GLASS SUBJECTS

Client *Heitman Retail Properties*
Design *WATCH! Graphic Design*
Art Director *Bruno Watel*
Designer *Tim Goldman*
Photographer *Hot Shots, Chicago*
Copywriter *Jay Dandy*

For product shots involving glass, try asking the photographer to use high-contrast lighting. The dramatic difference between specular highlights and deep shadows makes the glass glisten and intensifies the color. These effects can also be heightened during separation by increasing the contrast.

METAMURISM

Client *Mercedes-Benz: Personal Accessories Fall/Winter '97*
Design *Pinkhaus Design*
Art Director *Kristin Johnson*
Designer *Caroline Keavy*
Copywriter *Frank Cunningham*

Film is manufactured so it renders the colors of nature realistically – skintones, blue sky, beige sand, and green grass all usually look natural on film. However, film does not do as well when it tries to record artificial colors, such as those used to dye leather and cloth. The dyes can reflect a different part of the spectrum than our eyes see. When the film responds by recording these wavelengths of light, the visual colors become skewed in unpredictable ways. This is called metamurism. In such cases, be prepared to replace colors electronically, especially browns and greens.

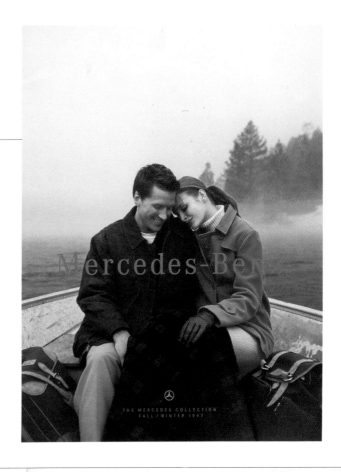

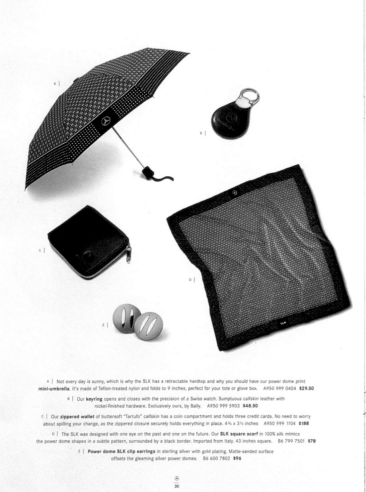

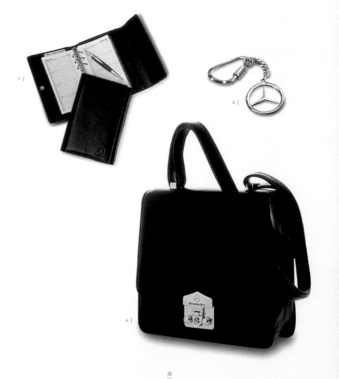

F | Our **Bally calfskin agenda** is sleeker and less bulky than most agendas, yet it holds eight credit cards and your year-at-a-glance. Two inside pockets and a secure snap closure (pen sold separately). 8 x 5¼ x 1½ inches D9701 7500 **$195**

G | The perfect gift, our **sterling silver medallion fob** is formed from solid silver bar stock. Gift-boxed. A950 999 5901 **$18.50**

H | Our stunning **handbag** is an exclusive design, with custom hardware and all the perfection of detail you'd expect from Bally. Made in Italy. Black calfskin 8 x 7½ x 3¾ inches A950 999 6603 **$450**

A | Not every day is sunny, which is why the SLK has a retractable hardtop and why you should have our power dome print **mini-umbrella**. It's made of Teflon-treated nylon and folds to 9 inches, perfect for your tote or glove box. A950 999 0404 **$29.50**

B | Our **keyring** opens and closes with the precision of a Swiss watch. Sumptuous calfskin leather with nickel-finished hardware. Exclusively ours, by Bally. A950 999 5903 **$48.50**

C | Our **zippered wallet** of buttersoft "Tartufo" calfskin has a coin compartment and holds three credit cards. No need to worry about spilling your change, as the zippered closure securely holds everything in place. 4¾ x 3½ inches A950 999 1104 **$188**

D | The SLK was designed with one eye on the past and one on the future. Our **SLK square scarf** in 100% silk mimics the power dome shapes in a subtle pattern, surrounded by a black border. Imported from Italy. 43 inches square. B6 799 7501 **$78**

E | **Power dome SLK clip earrings** in sterling silver with gold plating. Matte-sanded surface offsets the gleaming silver power domes. B6 600 7802 **$96**

30

31

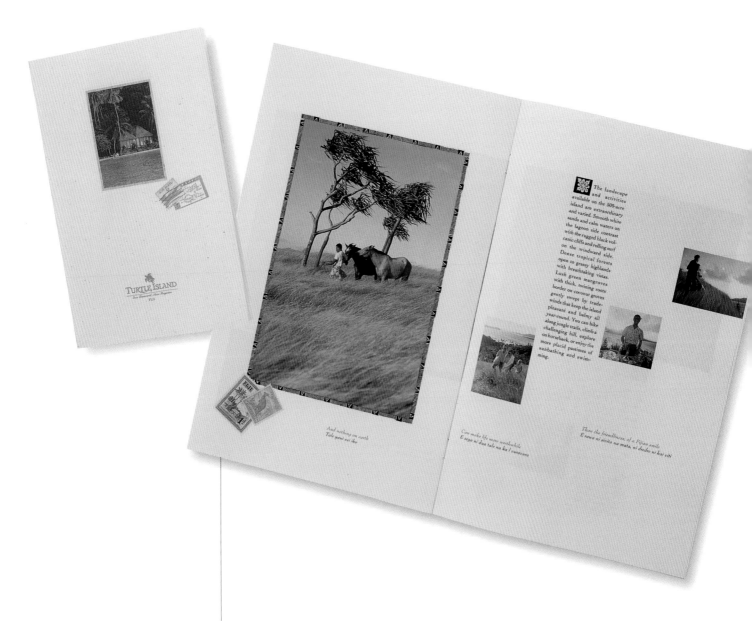

Note that the spread includes small text captions beneath the photographs:

And nothing on earth
Tale gani vei iko

Can make life more worthwhile
E sega ni dua tale na ka l vunavura

Than the friendliness of a Fijian smile
E rawa ni sivita na mata, ni dredre ni kai citi

THE COLOR OF LIGHT

Client	*Turtle Island*
Design	*KaiserDicken*
Art Directors	*Craig Dicken, Debra Kaiser*
Designers	*Craig Dicken, Debra Kaiser*

Lighting can skew colors more unpredictably than any
other factor. Outdoor light can have overtones of red
and yellow at dawn or dusk; blue at midday; and gray
during cloudy weather. Photos taken at such times
acquire a color cast that can be difficult to handle.
Electronically, a color cast can be removed overall,
but spot colors are then altered in unpredictable ways
that may require hours of keyboard time to fix. It
might be better to start with more balanced originals.
Or you can incorporate the color cast into the design,
as here. Note that the yellow cast of the large photo
is mimicked in all the small photos, too. The result
is a warm feeling that looks deliberate. Compare the
two-page spread with the more natural-appearing
cover and you can see the difference.

INDOOR SNAPS

Client *Centraal Museum, Utrecht*
Design *Wild Plakken*
Designer *Lies Ros*
Photographers *Ernst Moritz, Jasper Wiedeman, Hans Wilschut*

Indoor lighting is even trickier to control than outdoor light, because artificial lights add color that the camera "sees" differently than our eyes do. Photographers can use filters and special films to correct the differences, but the process is unpredictable and difficult. You can correct some color-skewing on your desktop, but this, too, is time-consuming and can produce unintended consequences. The technical term for such results is cattywumpus, as in "I don't know what happened to that photo – everything just got cattywumpus." You might have to settle for whitening the whites, making sure neutral grays and blacks stay neutral, and keeping skintones away from a green cast. Then let the rest go.

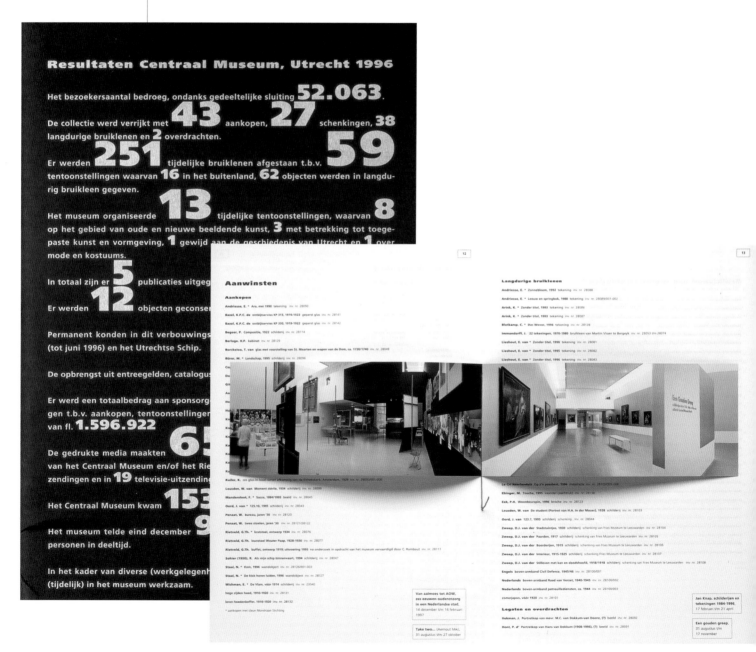

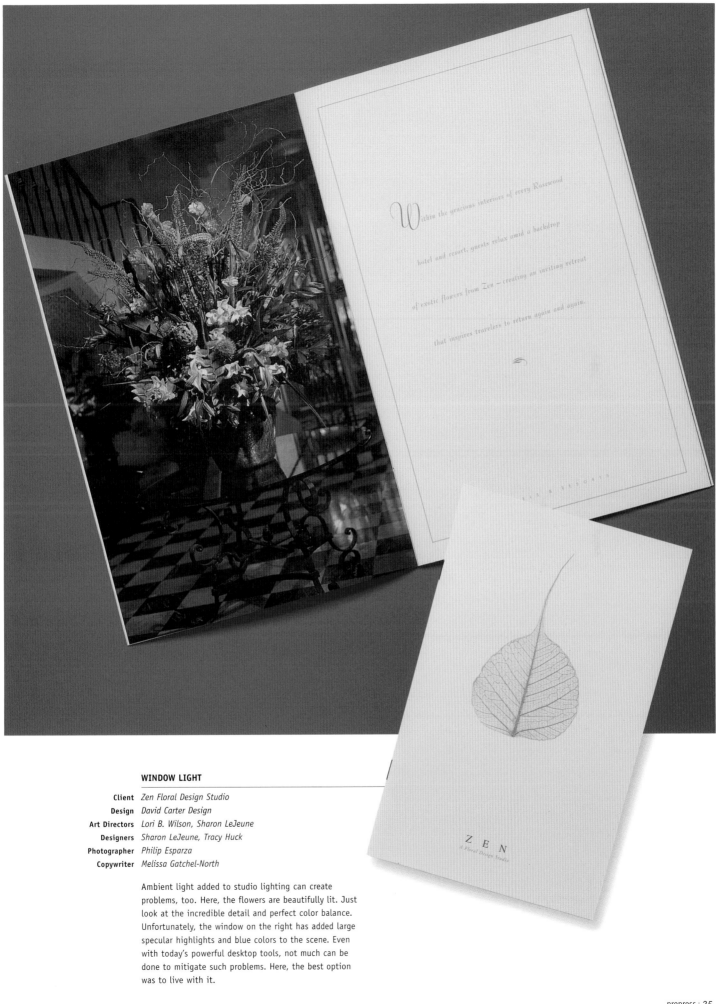

Within the gracious interiors of every Rosewood

hotel and resort, guests relax amid a backdrop

of exotic flowers from Zen — creating an inviting retreat

that inspires travelers to return again and again.

ZEN
A Floral Design Studio

WINDOW LIGHT

Client	Zen Floral Design Studio
Design	David Carter Design
Art Directors	Lori B. Wilson, Sharon LeJeune
Designers	Sharon LeJeune, Tracy Huck
Photographer	Philip Esparza
Copywriter	Melissa Gatchel-North

Ambient light added to studio lighting can create problems, too. Here, the flowers are beautifully lit. Just look at the incredible detail and perfect color balance. Unfortunately, the window on the right has added large specular highlights and blue colors to the scene. Even with today's powerful desktop tools, not much can be done to mitigate such problems. Here, the best option was to live with it.

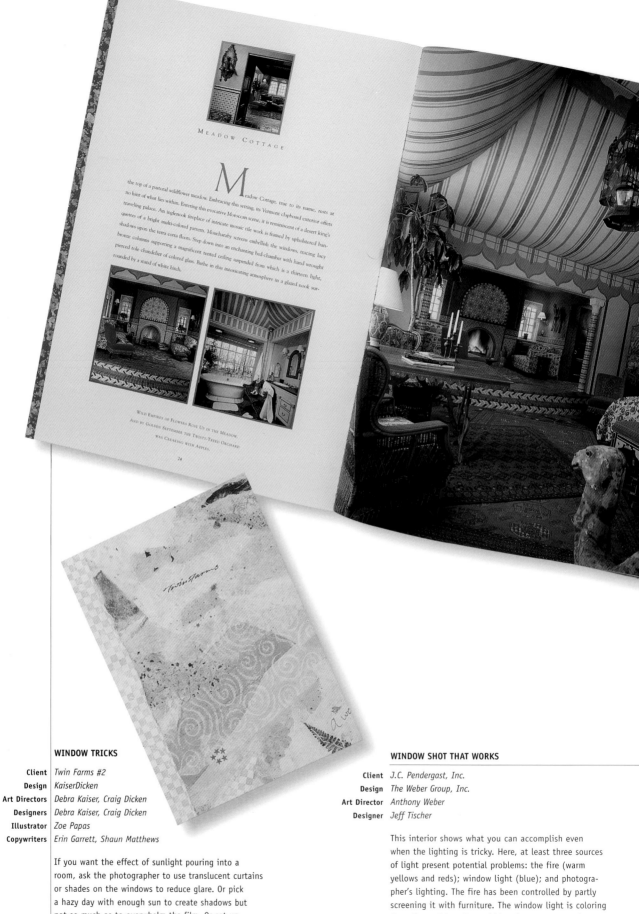

WINDOW TRICKS

Client	*Twin Farms #2*
Design	*KaiserDicken*
Art Directors	*Debra Kaiser, Craig Dicken*
Designers	*Debra Kaiser, Craig Dicken*
Illustrator	*Zoe Papas*
Copywriters	*Erin Garrett, Shaun Matthews*

If you want the effect of sunlight pouring into a room, ask the photographer to use translucent curtains or shades on the windows to reduce glare. Or pick a hazy day with enough sun to create shadows but not so much as to overwhelm the film. Or set up using a window that receives side lighting, as here. Then forget about enhancing any details of the outside landscaping – they would only detract from the main focus of the interior.

WINDOW SHOT THAT WORKS

Client	*J.C. Pendergast, Inc.*
Design	*The Weber Group, Inc.*
Art Director	*Anthony Weber*
Designer	*Jeff Tischer*

This interior shows what you can accomplish even when the lighting is tricky. Here, at least three sources of light present potential problems: the fire (warm yellows and reds); window light (blue); and photographer's lighting. The fire has been controlled by partly screening it with furniture. The window light is coloring the rafters with a tinge of blue, but not too much. The photographer has filled in shadows just enough to give a full range of tone while preserving detail. When so much care goes into making the original, reproducing the piece on press is easy.

CIGAR
Aficionado™

A. Collection
Timeless Furniture for a Timeless Pursuit

CLASSIC FLOOR ASHTRAY
Retro styling of the
1940's nightclub scene.
In black & chrome.

SOFA: 94"L x 39"D x 35"H
Loveseat also available

CHAIR: 39"L x 39"D x 31"H
OTTOMAN: 35"L x 23"D x 20"H

Inspired by the Gentlemen's Clubs of London from the 1920's.
J.C. Pendergast presents the Cigar Aficionado™ French Smoking chair, sofa and ottoman
reproduced from originals bought at the antique Paris flea market. Constructed of only the finest
time honored materials and techniques these chairs are sure to be as relaxing as your favorite cigar.
*Features include Imported Wax Pull-up Leather, Ultra Down Cushions, Eight Way Hand-tied Springs, Marshall Unit
Back Construction, 5/4 White Ash Frame, Antique Walnut Finish Legs & Imported Nailhead Trim from Paris.*

Available in Spring 1997 - Cigar Aficionado Humidor with automatic digitally controlled temperature & humidity
J.C. PENDERGAST, INC. 414-634-2388 FAX: 414-634-7791 2909 Wolff St. Racine, WI 53404
©1997 J.C. Pendergast, Inc.

FOOD SUBJECTS

Client *International Dining Adventures*
Design *Belyea Design Alliance*
Art Director *Patricia Belyea*
Designer *Christian Salas*

Food can be challenging to reproduce. The slightest color cast can make an entire spread appear unappetizing. If your photo has an overall color cast, as here, don't bother with overall fixes. Concentrate on the food itself. You can see that the table and plates have had some yellow removed (look at the white checks in the tablecloth). The food still has a slight yellow cast, but not enough to make it look unnatural.

FOOD FIGHTS

Client *Lindner, Gemüsegrosshändler*
Design *Buttgereit & Heidenreich, Kommunikationsdesign*
Designers *Wolfram Heidenreich, Michael Buttgereit*
Copywriters *Wolfram Heidenreich, Michael Buttgereit*

It is very important to color-balance food shots carefully before you get on press. Make sure that the color needs of one subject do not conflict with those of another. On the cover here, for example, the leafy veggies in the center are carrying too much cyan ink, while the strawberries below could use more (see the yellowish green of the strawberry leaves?). On press, your ability to balance these conflicts is extremely limited. You can try to compromise, or you can sacrifice one picture for another. Neither option is especially palatable.

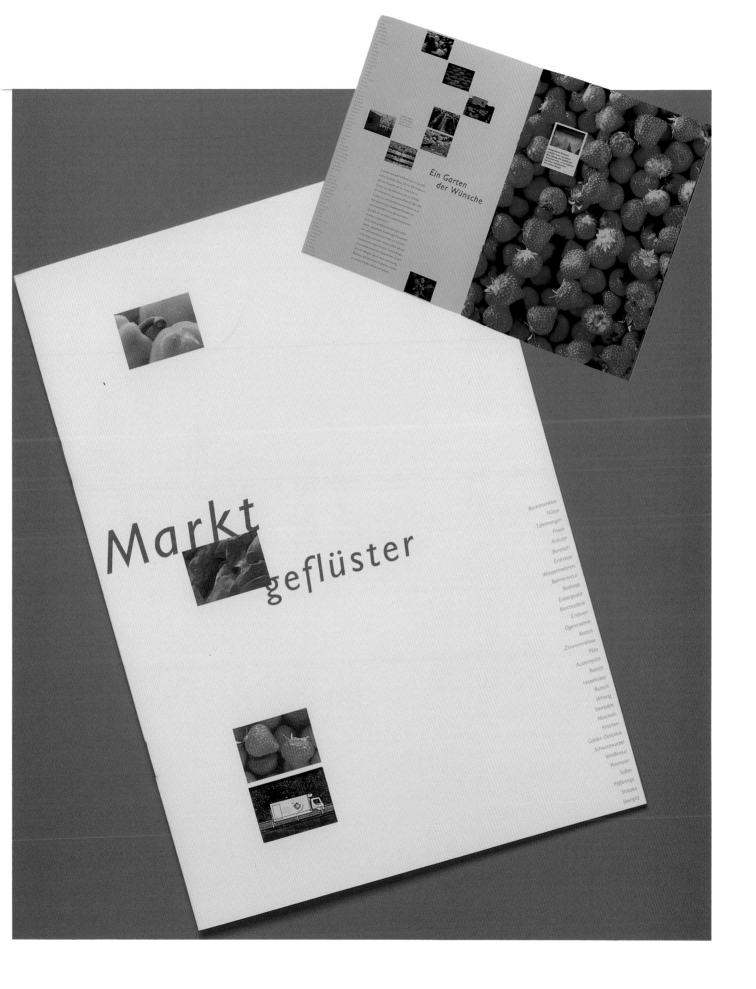

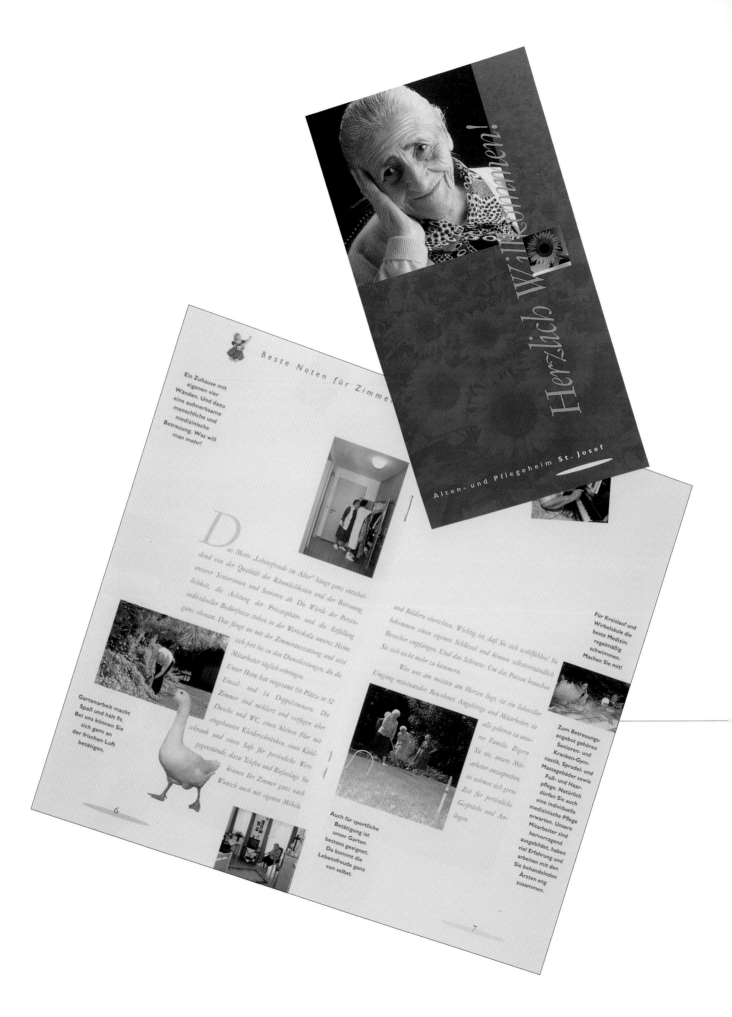

Herzlich Willkommen!

Alten- und Pflegeheim St. Josef

Beste Noten für Zimmer

Ein Zuhause mit eigenen vier Wänden. Und dazu eine aufmerksame menschliche und medizinische Betreuung. Was will man mehr?

D as Motto "Lebensfreude im Alter" hängt ganz entscheidend von der Qualität der Räumlichkeiten und der Betreuung unserer Seniorinnen und Senioren ab. Die Würde der Persönlichkeit, die Achtung der Privatsphäre und die Erfüllung individueller Bedürfnisse stehen in der Werteskala unseres Heims ganz obenan. Das fängt an mit der Zimmerausstattung und setzt sich fort bis zu den Dienstleistungen, die die Mitarbeiter täglich erbringen.

Unser Heim hat insgesamt 60 Plätze in 32 Einzel- und 14 Doppelzimmern. Die Zimmer sind möbliert und verfügen über Dusche und WC, einen kleinen Flur mit eingebautem Kleiderschränken, einen Kühlschrank und einen Safe für persönliche Wertgegenstände, dazu Telefon und Rufanlage. Sie können Ihr Zimmer ganz nach Wunsch auch mit eigenen Möbeln

and Bildern einrichten. Wichtig ist, daß Sie sich wohlfühlen! Sie bekommen einen eigenen Schlüssel und können selbstverständlich Besucher empfangen. Und das Schönste: Um das Putzen brauchen Sie sich nicht mehr zu kümmern.

Was uns am weitten am Herzen liegt, ist ein liebevoller Umgang miteinander. Bewohner, Angehörige und Mitarbeiter, sie alle gehören zu unserer Familie. Zögern Sie nie, unsere Mitarbeiter anzusprechen, sie nehmen sich gerne Zeit für persönliche Gespräche und Anliegen.

Gartenarbeit macht Spaß und hält fit. Bei uns können Sie sich gern an der frischen Luft betätigen.

Auch für sportliche Betätigung ist unser Garten bestens geeignet. Da kommt die Lebensfreude ganz von selbst.

Für Kreislauf und Wirbelsäule die beste Medizin: regelmäßig schwimmen. Machen Sie mit!

Zum Betreuungs-angebot gehören Senioren- und Kranken-Gymnastik, Sprudel- und Massagebäder sowie Fuß- und Haarpflege. Natürlich dürfen Sie auch eine individuelle medizinische Pflege erwarten. Unsere Mitarbeiter sind hervorragend ausgebildet, haben viel Erfahrung und arbeiten mit den Sie behandelnden Ärzten eng zusammen.

6

7

The Classics

TIMELESS WORKS OF ART

CHANTICLEER

These 12 men comprise an orchestra of voices. The sheer beauty of their sound stems from a seamless blend of carefully matched male voices, ranging from resonant bass to purest countertenor. The ensemble has thrilled audiences worldwide with its brilliance and its repertoire, which includes everything from Renaissance to jazz, gospel to new music. The only full-time classical voice ensemble in this country, Chanticleer has developed a remarkable reputation over an 18-year history for its interpretation of vocal literature. Revel as they do in the pleasure of song.

Sunday, October 6, 7:30pm

$25, $22, $18

MARK MORRIS DANCE GROUP

Here is one of the great choreographers of our time, considered a genius by many. His dance reverberates with wit, humor and lucid musicality. He breaks all the rules, even his own. Irreverent, iconoclastic and yet his work reveals a seriousness and deep understanding of dance. Morris is intensely musical, miraculously turning the classical works of Haydn and Vivaldi into the most contemporary of dances. According to *The Los Angeles Times*, Mark Morris "is deceptively cerebral, insinuatingly sensual, fabulously funky." Now, in the prime of his career, you can see the miracle of Mark Morris.

Sunday–Monday, October 13–14, 7:30pm

$35, $32, $27.50

MOSCOW FESTIVAL BALLET

Combining the best classical elements of two extraordinary companies, the Bolshoi and the Kirov, Artistic Director Sergei Radchenko has forged an exciting new company with some of Russia's leading dancers, including Prima

13

GOOD SKIN

Client Alten- und Pflegeheim St. Josef
Design Buttgereit & Heidenreich, Kommunikationsdesign
Designers Wolfram Heidenreich, Michael Buttgereit
Copywriters Wolfram Heidenreich, Michael Buttgereit

Skintones are another tricky color challenge. Caucasian or Asian skin can often reproduce with hot spots of reds or yellows, creating a sunburned look. This is especially true if the skin carries an equal amount of magenta and yellow. Many presses experience more dot gain in magenta ink than in yellow. When the press operator tries to compensate by boosting the yellow, the skintones become too warm. Make sure your proofs look exactly right before you get on press. You might even consider cutting back all midtone dots, expecting to gain them back on press. The photos here, especially the one on the cover, show perfectly balanced skintones, so beautiful they are almost luminescent.

HELP FOR SKIN

Client UNM Public Events Management
Design Vaughn Wedeen Creative
Art Director Rick Vaughn
Designer Rick Vaughn
Photographer UNM Public Events Management
Copywriter UNM Public Events Management

Skintones are easier to control on press when you don't have to worry about other color-balance problems. Here, greater flexibility with the skintones can be achieved by replacing the dense, four-color process shadows with solid black ink (undercolor removal).

Client and Design	*Blackfish Creative*
Art Director	*Drew Force*
Designer	*Drew Force*
Illustrators	*Juan Calvillo, Greg Kozawa*
Copywriters	*Keith Danziger, Drew Force*

Note how easy it would be for these skintones to gain too much warmth. Yet they have been balanced during prepress so the men look tan, not sunburned.

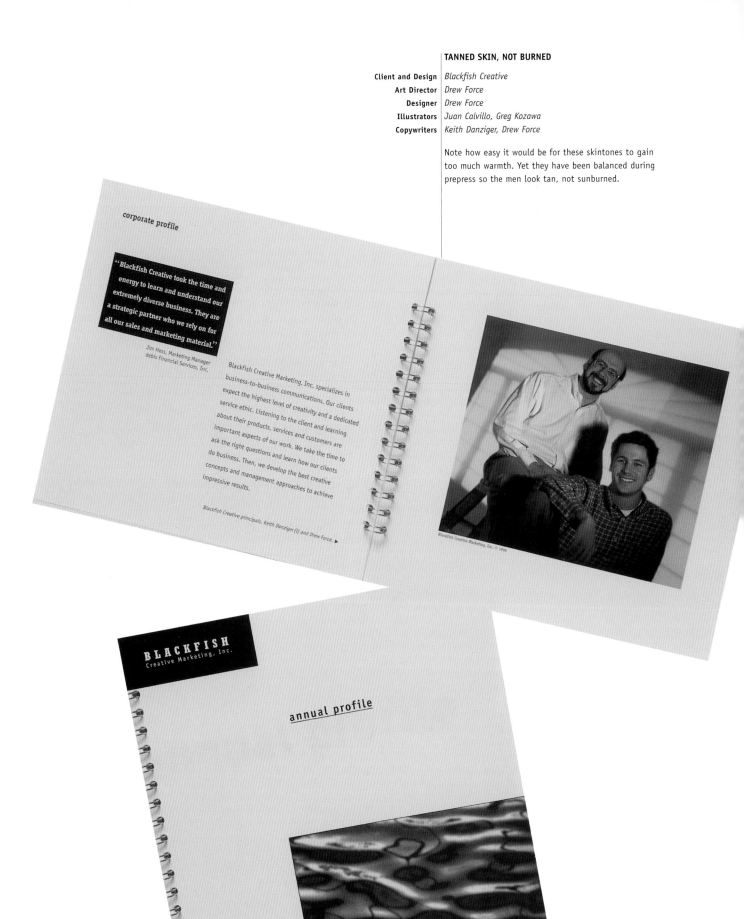

corporate profile

"Blackfish Creative took the time and energy to learn and understand our extremely diverse business. They are a strategic partner who we rely on for all our sales and marketing material."

Jim Hess, Marketing Manager
debis Financial Services, Inc.

Blackfish Creative Marketing, Inc. specializes in business-to-business communications. Our clients expect the highest level of creativity and a dedicated service ethic. Listening to the client and learning about their products, services and customers are important aspects of our work. We take the time to ask the right questions and learn how our clients do business. Then, we develop the best creative concepts and management approaches to achieve impressive results.

Blackfish Creative principals, Keith Danziger (l) and Drew Force. ▶

Blackfish Creative Marketing, Inc. © 1996

BLACKFISH
Creative Marketing, Inc.

annual profile

SPF 40 NEEDED

Client	*Swank Shop*
Design	*Alan Chan Design Company*
Art Director	*Alan Chan*
Designers	*Alan Chan, Miu Choy, Pamela Low*
Copywriter	*Lam Ping Ting*

This design is especially tricky because the red chair demands heavy ink coverage in magenta and yellow. Look how carefully the skintones have been balanced so they remain natural, despite the high ink saturation.

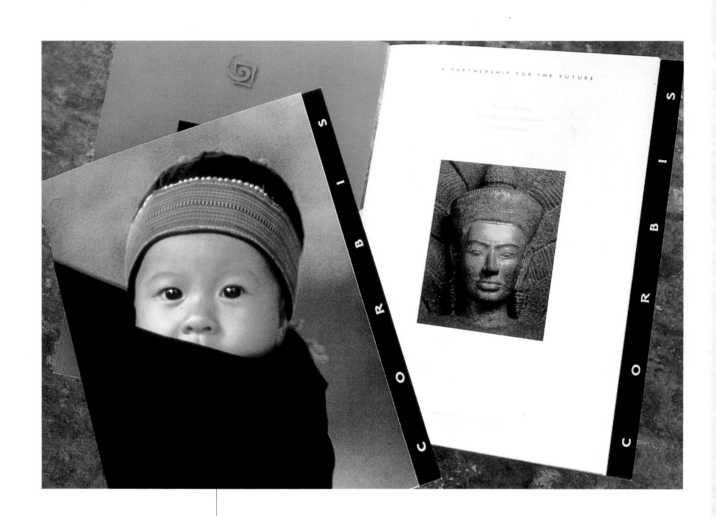

WARM SKIN

Client	Corbis Corporation
Design	Hornall Anderson Design Works Inc.
Art Director	Jack Anderson
Designers	Jack Anderson, John Anicker, David Bates, Margaret Long
Illustrator	Corbis archive

The skintones here are not helped by the excess of yellow. As a model shot, this photo would probably not work. As an abstract study in black and orange for an art audience, it is attractive.

OKAY TO BE VULCAN

Client | hi-p (CD album cover)
Design | Higraph Tokyo
Designer | Ichiro Higashiizumi

Sometimes a design calls for odd skintones. Don't be afraid to enter the realm of the abstract, as long as it's clear you meant to do so. Here, the model's skin has taken on a distinct greenish cast, but that only contributes to the modernist design.

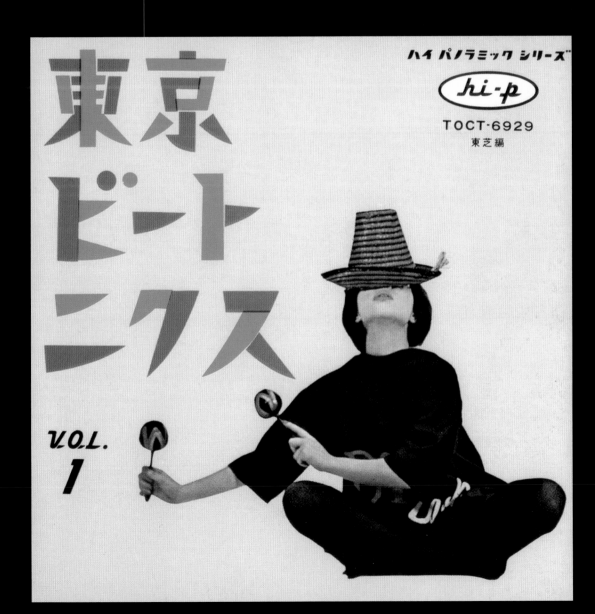

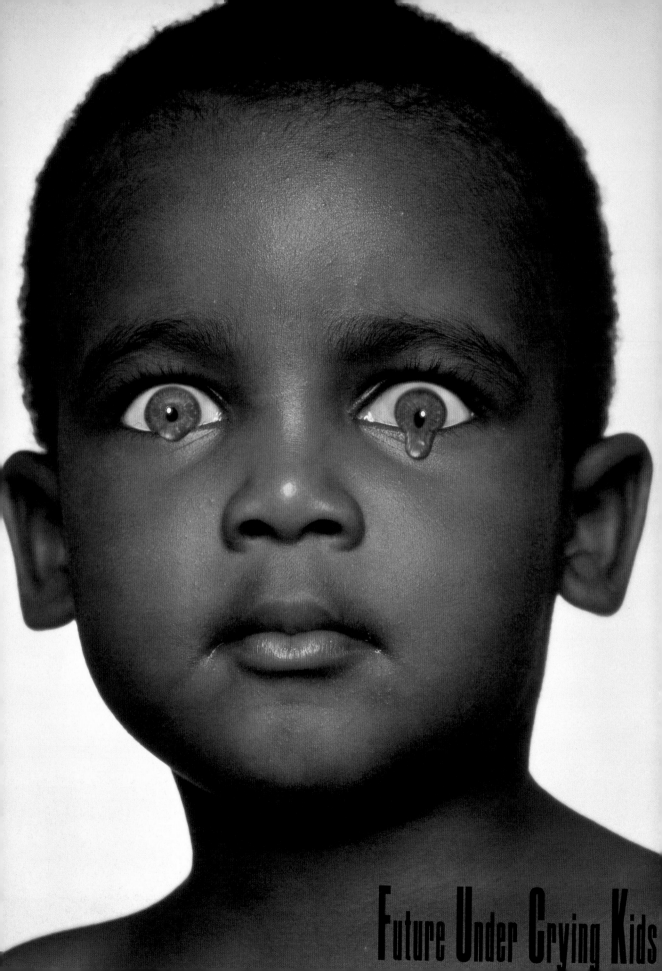

Future Under Crying Kids

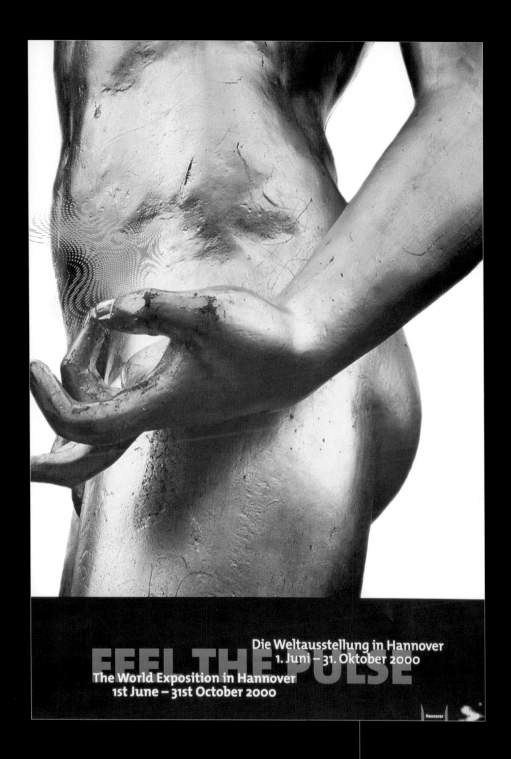

Die Weltausstellung in Hannover
1. Juni – 31. Oktober 2000
The World Exposition in Hannover
1st June – 31st October 2000

FEEL THE PULSE

Hannover

MIDTONE BRIDGES

Client	*Tokyo Art Directors Club*
Design	*Seiju Toda*
Copywriter	*Jun Maki*
Typographer	*Jun Maki*
Photographer	*Kazumi Kurigami*

Notice how beautifully this skin has been balanced.
The press has picked up just a touch of green cast
on the lower right, but it isn't much. One reason
why African skin is hard to reproduce well is that
many of the midtones hover right at the 50 percent
level. Whenever a screened halftone is at 50 percent,
the dots just "kiss" each other at the corners. The
least bit of dot gain causes a bridge of ink to form
between the dots, boosting the dot size up rapidly
and uncontrollably.

SMOOTH TONES

Client	*City of Hannover*
Design	*Maviyane-Project*
Designer	*Chaz Maviyane-Davies*
Photographer	*Chaz Maviyane-Davies*

One way to avoid the 50 percent problem and smooth
out tonal breaks is to use elliptical dots for halftone
screens, instead of square dots. Photos with large areas
of smooth metal (as here) or closeups of skintones are
good candidates for elliptical dots.

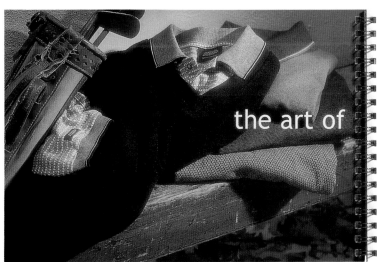

the art of looking good.

GOLF • The JJM Tour Line goes the distance
with soft, 100% cotton lightweight fabrics, subtle
patterns and rich hues. The Tour Line embodies
a refined style and easy comfort that won't
leave you in the rough.

It's all about style and quality – it's about being noticed.
We're in the business of dressing up your corporate image.
More specifically, we design, manufacture and customize
garments for companies worldwide.

Our garments are created with careful attention
to the smallest detail. Choose from a discerning
two-button placket or make a statement with a
stylish zippered closure. Our golf shirts will
bring you in under par, with labels strategically
placed on the right sleeve, to help prevent
hooks or slices.

STOCHASTIC SCREENING

Client	*La Boite Theatre*
Design	*Inkahoots Design*
Art Director	*Jason Grant*
Designer	*Jason Grant*
Illustrator	*Donna Kendrigan*

Stochastic screening is another way to smooth
out tonal breaks and preserve subtle detail. Unlike
traditional halftone screens, which use different-sized
dots arranged in a square grid, stochastic screens
use tiny pin dots randomly arranged without pattern.
Because of their size and lack of pattern, stochastic
dots are especially effective for smooth midtones and
highly detailed art. However, be sure your printer
runs a very clean operation; otherwise, the pin dots
could get lost in the plating process.

SMOOTH PAPER

Client	*JJM Manufacturing*
Design	*The Riordon Design Group Inc.*
Art Director	*Ric Riordon*
Designers	*Dan Wheaton, Shirley Riordon,*
	Greer Hutchison, Sharon Pece
Photographer	*Robert Lear*
Copywriters	*Shirley Riordon, Dan Wheaton, Greer Hutchison*

When you specify stochastic screening, make sure the
paper you select has a very smooth finish. Stochastic
dots are so small that they disappear into the crevices
of a textured sheet. Most printers prefer that stochastic
screens be printed on high-quality coated stock,
but smooth-finished uncoated paper is also possible.
Here, Supreme Gloss Cover and Glama Vellum work
equally well.

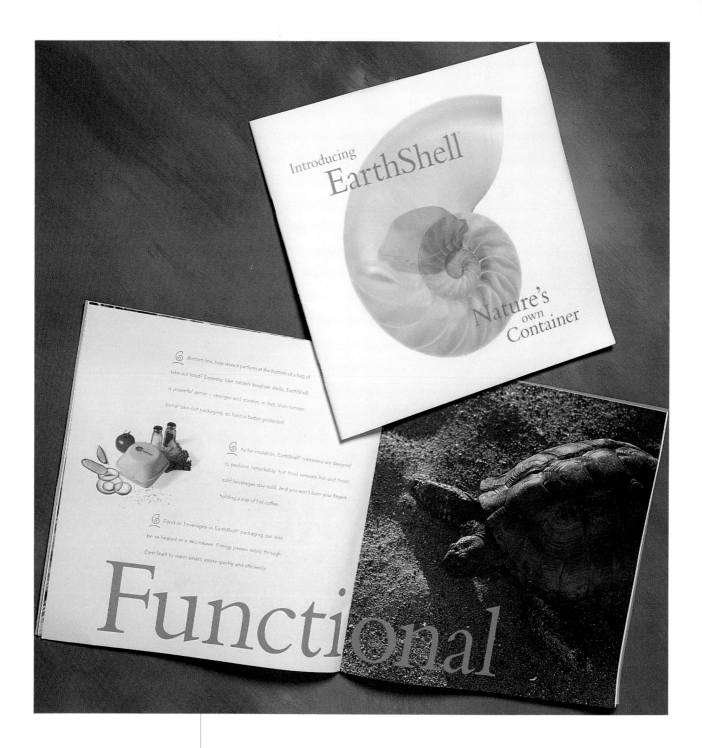

WHITER WHITES

Client	*EarthShell Container Corp.*
Design	*Hornall Anderson Design Works Inc.*
Art Director	*John Hornall*
Designers	*John Hornall, Jana Nishi, Bruce Branson-Meyer*
Illustrator	*Julia LaPine*

Some subjects require special attention during prepress; white is such a subject. In offset printing, whites are printed by using four-color inks, which sounds impossible. And, of course, it is. To create the illusion of pure white, you must rely on subtle halftones of four-color, made up of tiny dots that the eye can compare to more colorful or darker areas. In this shell, for example, we see the top part as pure white because the bottom part has a pinkish cast. It's the comparison that lets us perceive white, because, in reality, the only white here is the white paper.

BLONDES

Client	*Elite Industries Ltd.*
Design	*Vardimon Design*
Art Director	*Yarom Vardimon*
Designers	*Yarom Vardimon, D. Goldberg, G. Ron*
Photographer	*Avi Ganor*
Copywriter	*Copirite Y. Fachler*

Blond hair is difficult to reproduce because it is assembled from the process colors in fairly equal proportions, with no single ink dominant. As long as the yellow, magenta, and cyan inks remain in balance, blond hair will reproduce as a neutral. But problems arise on press if dot gain in one ink causes that color to become dominant. Since most presses gain more heavily in magenta and also cyan, blond hair often assumes a red or green cast. You can compensate for this in prepress if you communicate your concerns to the printer ahead of time.

CLEAN SNOW

Client	*Victoria Travel*
Design	*Issen Okamoto Graphic Design Co., Ltd.*
Art Director	*Issen Okamoto*

Be careful of excessive color casts when you work with whites. If your original has a color cast, try substituting a little black for cyan and magenta. Too much black, however, can make whites look dirty.

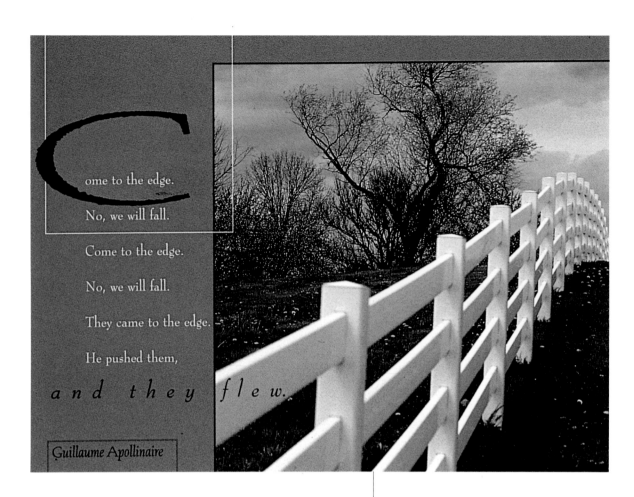

Come to the edge.

No, we will fall.

Come to the edge.

No, we will fall.

They came to the edge.

He pushed them,

and they flew.

Guillaume Apollinaire

PURE WHITE

Client	*Spring Hollow*
Design	*Held Diedrich*
Art Director	*Doug Diedrich*
Designer	*Megan Snow*

This white fence has plenty of color. However, it looks pure white because it has no color cast and because it is positioned in contrast to a dense background.

BLACKEST BLACK

Client	*Brooklyn Academy of Music*
Design	*BAMdesign*
Design Consultant	*Michael Bierut*
Art Director	*Rafael Weil*
Designer	*Jason Ring*
Photographer	*Brigitte Lacombe*

Black subjects are almost as tough to reproduce as white ones. Black subjects must retain density, as well as neutrality and detail. Ask your photographer to shoot with Fujichrome or Ektachrome film, both of which preserve detail in blacks. Then separate using undercolor removal, maximizing details in the deep shadows.

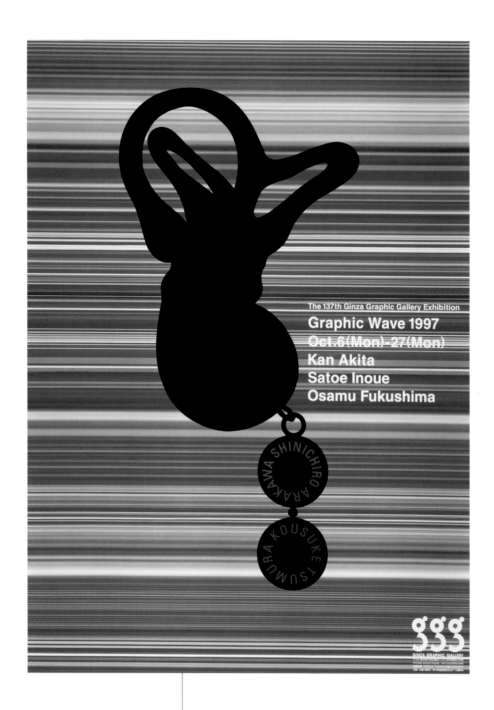

The 137th Ginza Graphic Gallery Exhibition

Graphic Wave 1997
Oct.6(Mon)–27(Mon)
Kan Akita
Satoe Inoue
Osamu Fukushima

ggg

SILHOUETTES WITH DETAIL

Client	*Ginza Graphic Gallery*
Design	*Osamu Fukushima*
Art Director	*Osamu Fukushima*
Illustrator	*Osamu Fukushima*

When you print silhouettes or back-lit subjects, pay attention to how much detail you want in the deep shadow. A little detail, enhanced perhaps on your desktop, can give a silhouette contour.

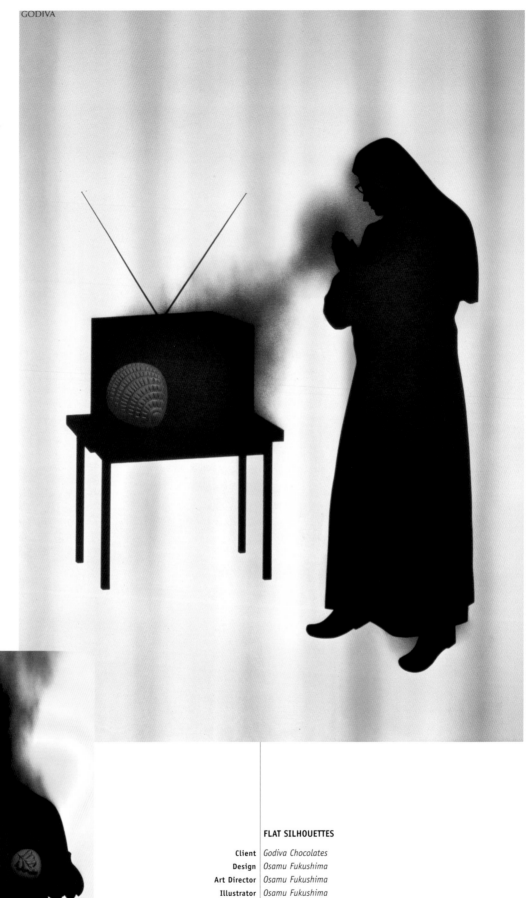

FLAT SILHOUETTES

Client	*Godiva Chocolates*
Design	*Osamu Fukushima*
Art Director	*Osamu Fukushima*
Illustrator	*Osamu Fukushima*

Silhouettes with no detail can be effective, too. They look a bit flat, but they do produce dramatic shapes. When you scan these types of silhouettes, make sure any detail that does appear in the photo is eliminated.

BACK-LIT DETAILS

Client	Sealaska Corporation
Design	Hornall Anderson Design Works Inc.
Art Director	Jack Anderson
Designers	Jack Anderson, Katha Dalton, Heidi Favour, Nicole Bloss, Michael Brugman
Illustrators	Sealaska archive
Photographers	Sealaska archive; also, David Perry, Mark Kelley, Clark Mishler, Image Bank, Alaska Historic Museum, University of Washington

Whether a back-lit subject has detail or not is a matter of artistic taste, not technical reality. Nowadays, even the most minute shred of detail can be eked out of a transparency, if it's there at all. In a photo like this one, the designer should be the one to decide whether to pull out some detail to make the scene look realistic, or eliminate detail to make the scene more abstract. Once that decision is made, it's up to production staff to deliver the desired result.

NO CAN DO

Client	Bentley College, Student Activities
Design	Bentley College, Communication and Publications
Art Director	Amy Coates
Copywriter	Jennifer Spira

Some colors are impossible to print with ordinary four-color process inks. Rich greens, hot purples, and deep reds just aren't on the palette. For these colors, consider adding a touch plate with a custom ink. Or specify an entirely different process. Here, the rich red of the balloon was achieved on a digital press.

AFFECTION CHRONIQUE

A BETTER YELLOW

Client and Design | *Muriel Paris et Alex Singer*
Art Directors | *Muriel Paris, Alex Singer*
Designers | *Muriel Paris, Alex Singer*

Dense yellow without a red cast is almost impossible
to reproduce on a four-color press. Even at 100 percent,
yellow ink is nearly transparent. To make yellow show
up, try adding a hint of magenta.

FLUORESCENT INK

Client	Sun Microsystems, Inc.
Design	Directech, Inc.
Art Director	Richard Johnson
Assistant Designer	Jeff McAllister
Illustrator	Ken Condon

If you can add a fifth unit on press, you can beef up process yellow by using fluorescent yellow ink. It is opaque and richly tinted and can be added as a touch plate to a normal separation. Or you can ask your printer to mix some flourescent ink into the process-ink fountain.

COLOR CONSISTENCY

Client	*IBM (Cobol-Visual Age)*
Design	*The Riordon Design Group Inc.*
Art Director	*Claude Dumoulin (FCB Toronto)*
Designer	*Dan Wheaton*
Illustrator	*Dan Wheaton*

If consistency of color is important—as it almost always is in a full-blown campaign—then consider specifying custom inks. Custom inks are easier to deal with on press because you don't have built-up screens that would experience variable dot gain on different presses. Even so, you need to pay attention to how paper affects color. Notice how different paper surfaces affect the colors of this campaign.

LOGO COLORS

Client Seattle Seahawks
Design Jeff Fisher LogoMotives
Creative Director Sara Perrin (Seattle Seahawks)
Copywriter Sara Perrin (Seattle Seahawks)
Designer Jeff Fisher
Illustrator Jeff Fisher

Logos are another subject where consistency of color
is important. Four-color process inks cannot produce
consistent screen colors. Even on the same paper,
different presses experience different levels of dot
gain, different papers accept ink more or less on the
surface; even humidity plays a role. This job for the
Seattle Seahawks was printed with six colors, including
the blue and green logo colors of the team.

FLAT SCREEN TINTS

Client	*Interchange Family Services*
Design	*Melissa Passehl Design*
Designer	*Melissa Passehl*
Illustrator	*Melissa Passehl*

Another time to consider using custom ink is when your design calls for broad areas of flat screen colors. Offset presses feed ink onto moving rollers through individual ink fountains spaced across the width of a press unit. Each fountain can be controlled independently – and each behaves a little independently, too. Variations in dot gain are the inevitable result, especially if the design employs screened tints rather than solids. Usually, such variations are masked by the busyness of a given design. But when the design is mostly flat color across a full page, variations show up clearly. In such cases, you're better off using a custom ink at 100 percent.

The goal of Interchange is to promote appropriate and coordinated services for families and their infants and toddlers who have special needs or are at risk of developmental delays.

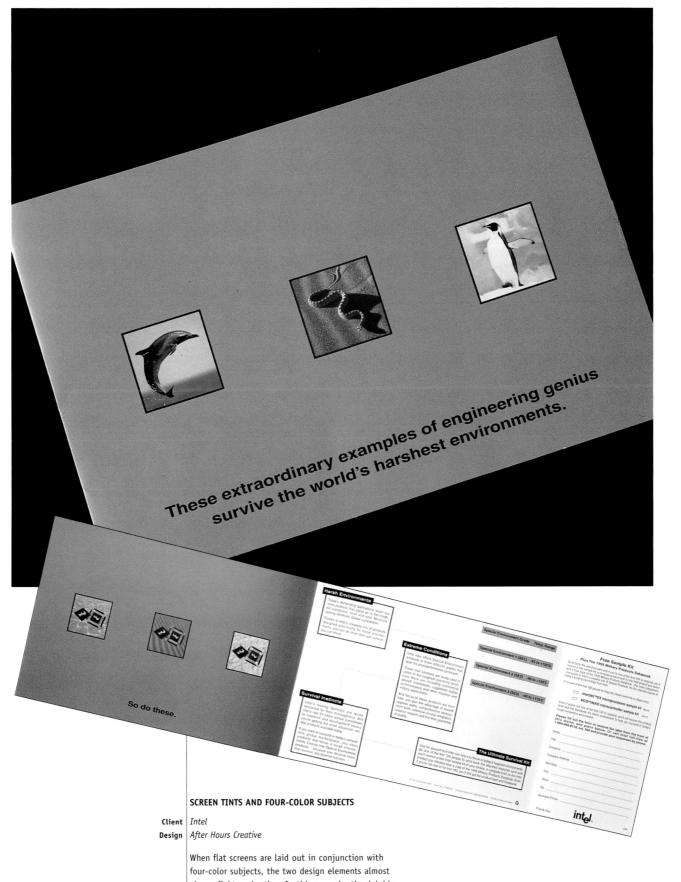

SCREEN TINTS AND FOUR-COLOR SUBJECTS

Client | *Intel*

Design | *After Hours Creative*

When flat screens are laid out in conjunction with
four-color subjects, the two design elements almost
always fight each other. In this example, the dolphin
might need less magenta and the penguin more,
but the magenta in the background screen must stay
the same across the entire page. Something's got
to give, and usually it's the four-color subjects that
are sacrificed. A fifth-color background tint solves
this problem.

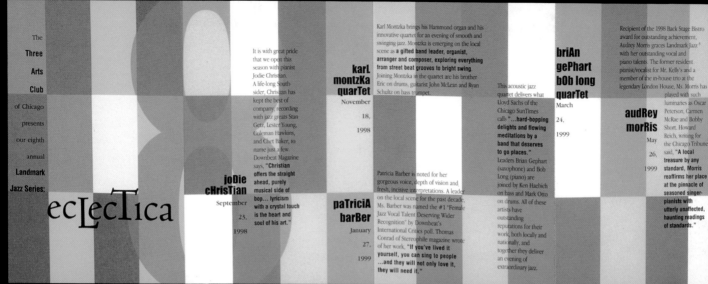

The Three Arts Club of Chicago presents our eighth annual Landmark Jazz Series:

ecLecTica

It is with great pride that we open this season with pianist Jodie Christian. A life-long South-sider, Christian has kept the best of company, recording with jazz greats Stan Getz, Lester Young, Coleman Hawkins, and Chet Baker, to name just a few. Downbeat Magazine says, "Christian offers the straight ahead, purely musical side of bop... lyricism with a crystal touch is the heart and soul of his art."

joDie cHrisTian
September 23, 1998

Karl Montzka brings his Hammond organ and his innovative quartet for an evening of smooth and swinging jazz. Montzka is emerging on the local scene as a gifted band leader, organist, arranger and composer, exploring everything from street beat grooves to bright swing. Joining Montzka in the quartet are his brother Eric on drums, guitarist John McLean and Ryan Schultz on bass trumpet.

karL montzKa quarTet
November 18, 1998

Patricia Barber is noted for her gorgeous voice, depth of vision and fresh, incisive interpretations. A leader on the local scene for the past decade, Ms. Barber was named the #1 "Female Jazz Vocal Talent Deserving Wider Recognition" by Downbeat's International Critics poll. Thomas Conrad of Stereophile magazine wrote of her work, "If you've lived it yourself, you can sing to people ...and they will not only love it, they will need it."

paTriciA barBer
January 27, 1999

This acoustic jazz quartet delivers what Lloyd Sachs of the Chicago SunTimes calls "...hard-bopping delights and flowing meditations by a band that deserves to go places." Leaders Brian Gephart (saxophone) and Bob Long (piano) are joined by Ken Haebich on bass and Mark Otto on drums. All of these artists have outstanding reputations for their work, both locally and nationally, and together they deliver an evening of extraordinary jazz.

briAn gePhart bOb long quarTet
March 24, 1999

Recipient of the 1998 Back Stage Bistro award for outstanding achievement, Audrey Morris graces Landmark Jazz with her outstanding vocal and piano talents. The former resident pianist/vocalist for Mr. Kelly's and a member of the in-house trio at the legendary London House, Ms. Morris has played with such luminaries as Oscar Peterson, Carmen McRae and Bobby Short. Howard Reich, writing for the Chicago Tribune said, "A local treasure by any standard, Morris reaffirms her place at the pinnacle of seasoned singer-pianists with utterly unaffected, haunting readings of standards."

audRey morRis
May 26, 1999

TWO-COLOR CONTROL

Client *The Three Arts Club of Chicago*
Design *WATCH! Graphic Design*
Designer *Carolyn Chester*

Although this job looks very colorful, only two custom inks, plus black, were used. By restricting the number of screen tints, the designer was able to achieve the control she needed to reproduce a design with touchy in-line problems.

CUSTOM INKS

Client *Anacomp*
Design *Mires Design Inc.*
Art Director *John Ball*
Designer *Deborah Hom*
Illustrator *Tracy Sabin*
Photographers *John Still, Michael Campos stock*
Copywriters *Danniel White, Steve Miller*

This job was printed on a six-unit press. Notice how much control over the four-color process subjects the designer has when she doesn't have to worry about matching some very difficult tinted bars.

prepress | 53

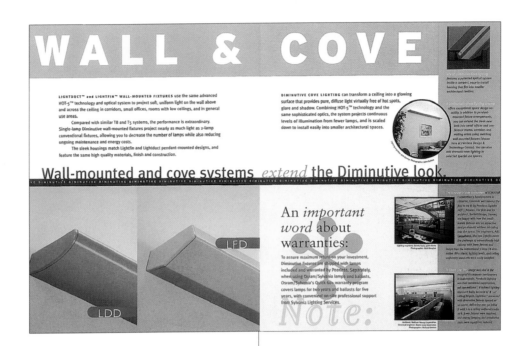

WALL & COVE

LIGHTDUCT™ and LIGHTFIN™ WALL-MOUNTED FIXTURES use the same advanced HOT-5™ technology and optical system to project soft, uniform light on the wall above and across the ceiling in corridors, small offices, rooms with low ceilings, and in general use areas.

Compared with similar T8 and T5 systems, the performance is extraordinary. Single-lamp Diminutive wall-mounted fixtures project nearly as much light as 2-lamp conventional fixtures, allowing you to decrease the number of lamps while also reducing ongoing maintenance and energy costs.

The sleek housings match Lightfin and Lightduct pendant-mounted designs, and feature the same high quality materials, finish and construction.

DIMINUTIVE COVE LIGHTING can transform a ceiling into a glowing surface that provides pure, diffuse light virtually free of hot spots, glare and shadow. Combining HOT-5™ technology and the same sophisticated optics, the system projects continuous levels of illumination from fewer lamps, and is scaled down to install easily into smaller architectural spaces.

Wall-mounted and cove systems *extend* **the Diminutive look.**

An *important* *word* about warranties:

To assure maximum return on your investment, Diminutive fixtures are shipped with lamps included and warranted by Peerless. Separately, when using Osram/Sylvania lamps and ballasts, Osram/Sylvania's Quick 60+ warranty program covers lamps for two years and ballasts for five years, with convenient on-site professional support from Sylvania Lighting Services.

Note:

EASY TINTS

Client	*Peerless Lighting Corporation*
Design	*JD Thomas Company*
Designer	*Clive Piercy*
Copywriter	*Jim Thomas*

If you can't afford to pay for an extra unit on press and you still want to use screened tints as a design element, then choose a tint made with only one or two process colors. In this layout, the blue tint (assembled from two process colors) is much easier to control on press than the brown tints (assembled from three or four process colors).

NEUTRAL TINTS

Client | Volkshochschulheim Inzigkofen
Design | revoLUZion
Designer | Bernd Luz
Photographer | Bernd Luz
Copywriter | Bernd Luz

Neutral tints made from more than two process colors are the hardest to control on press, because the least inconsistency in dot gain shifts the entire color to a new hue. You might get away with such a tint if you color-balance the four-color subjects thoroughly, though I wouldn't like to try it. Problems multiply if you have to deal with crossovers. You can help yourself by laying out such a crossover in the center spread, where at least you won't have to contend with extraneous in-line conflicts.

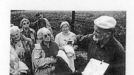

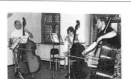

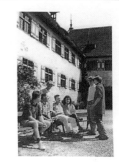

Das Volkshochschulheim Inzigkofen ist eine unabhängige, überkonfessionelle und überparteiliche Einrichtung der freien Erwachsenenbildung und wird getragen vom Verein "Volkshochschulheim Inzigkofen e.V." Finanziell und ideell unterstützt wird es vom Land Baden-Württemberg und einem Freundeskreis, der sich aus begeisterten Kursteilnehmern und Dozenten gebildet hat.

KONTAKTE KNÜPFEN

HORIZONTE ERWEITERN

Die ruhige Umgebung und die besondere Atmosphäre des Hauses bieten beste Voraussetzungen für konzentriertes Arbeiten, für Gespräche und Entspannung. Unser Ziel ist es einerseits, Erwachsenen eine umfassende Allgemeinbildung sowie die Fähigkeit zu selbständigem, kritischen und zukunftsorientierten Denken und Handeln in unserer Gesellschaft zu vermitteln, andererseits die individuellen Begabungen des Einzelnen zu fördern und so die positive Entfaltung seiner Persönlichkeit zu unterstützen.

WISSBEGIERDE BEFRIEDIGEN

IN SICH GEHEN

- AUS SICH HERAUS GEHEN

Sie wohnen bei uns in den ehemaligen Nonnenzellen, die jetzt als 32 Einzelzimmer, sieben Doppel- und zwei Familienzimmer eingerichtet sind.

UNTERKUNFT & VERPFLEGUNG

Alle Zimmer sind konsequent einfach eingerichtet, verfügen über fließend Warmwasser und wirken ganz besonders durch ihre Butzenscheiben und individuell gestalteten Stuck- oder Holzkassettendecken. Außerdem stehen zehn komfortable Einzelduschen zur Verfügung. Unsere Küche versorgt Sie mit vier Mahlzeiten pro Tag, immer frisch und mit Liebe zubereitet. Sie haben die Wahl zwischen bürgerlicher Normal- und vegetarischer Kost. Alle Kurse können aber auch ohne Übernachtung und Verpflegung gebucht werden.

AKTIVER URLAUB

HISTORISCHES AMBIENTE

NATUR

Kennenlernen von Blütenpflanzen, Bäumen, Sträuchern, Moosen, Flechten, Pilzen, Vögeln, Insekten, Plankton, Versteinerungen und Gesteinen, sowie erkunden von Landschaften und ökologischen Zusammenhängen.

MUSIK

Musik hören, erleben und verstehen. Musizieren in kleinen Ensembels und großen Orchestern. Gesangs- und Instrumentalunterricht von Klassik bis Jazz.

KÖRPER & GEIST

Ganzheitliche Methoden im Gesundheitsbereich, wie Yoga, Autogenes Training, Tai Chi Chuan, Qigong, Feldenkrais, Meditation, Heilfasten, Spiel und Tanz.

FREMDSPRACHEN

Intensivkurse in Englisch, Französisch, Italienisch und Spanisch. Zum Teil nach der Suggestopädiemethode mit speziellen Entspannungsübungen.

KÜNSTLERISCHES GESTALTEN

Grund-, Aufbau- und Fortgeschrittenenkurse für Malen und Zeichnen in den unterschiedlichsten Techniken und Themen; Radierung, Holzschnitt, Kalligraphie, Fotografie und Modellieren mit Ton.

GESCHICHTE & KULTURGESCHICHTE

Europäische Geschichte, Kunst und Kultur von der Steinzeit bis zur Moderne: die Lebenswelt der "kleinen und großen Leute", Philosophie, Musik, Literatur, Kunst- und Bauwerke der jeweiligen Epoche.

GESELLSCHAFT

Umweltschutz, Rhetorik, Erziehung, Politik, Soziales

HANDWERK

Buchbinden, Krippenbau, Klöppeln, Spinnen u. Weben

LITERATUR & SCHREIBEN

Literatur verschiedenster Epochen und Gattungen. Gedichte, Kurzgeschichten, Erzählungen, Märchen oder Autobiographisches selber schreiben.

DOMINANT COLOR

Client	*HBO*
Design	*SJI Associates Inc.*
Art Director	*Susan Seers*
Designer	*Karen Lemke*
Copywriter	*Jessy Vendley*

Multiple-screen tints can work well if you specify tints that have a dominant process color. The dominant ink masks small variations in dot gain.

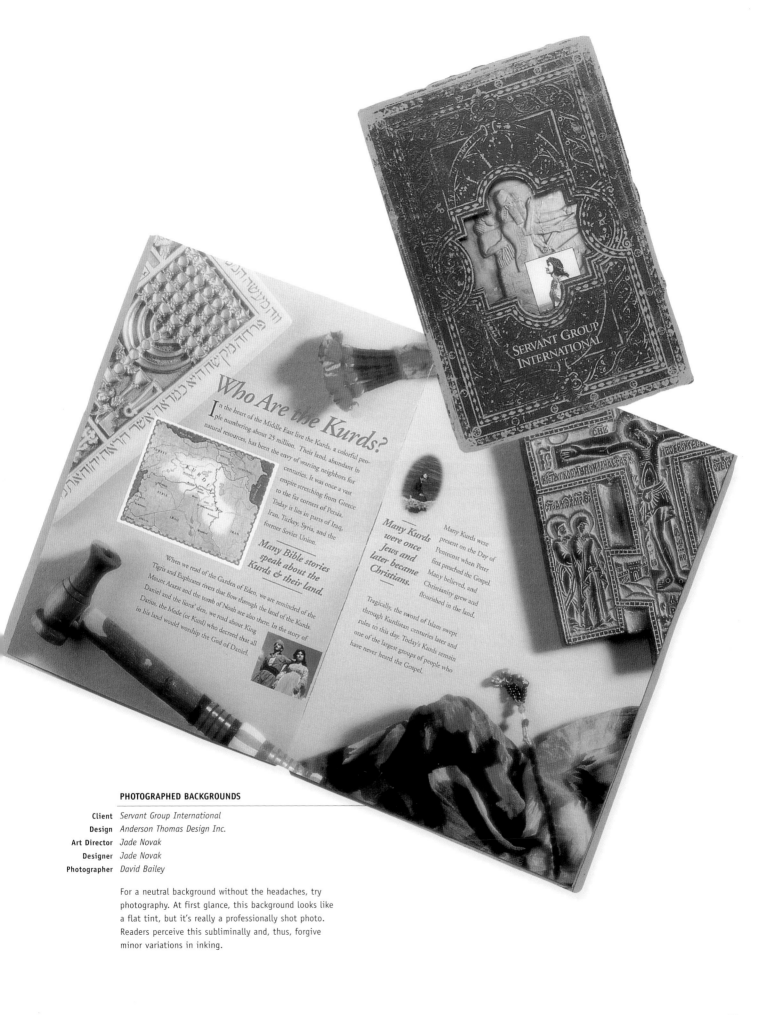

Who Are the Kurds?

In the heart of the Middle East live the Kurds, a colorful people, numbering about 25 million. Their land, abundant in natural resources, has been the envy of warring neighbors for centuries. It was once a vast empire stretching from Greece to the far corners of Persia. Today it lies in parts of Iraq, Iran, Turkey, Syria, and the former Soviet Union.

Many Bible stories speak about the Kurds & their land.

When we read of the Garden of Eden, we are reminded of the Tigris and Euphrates rivers that flow through the land of the Kurds. Mount Ararat and the tomb of Noah are also there. In the story of Daniel and the lions' den, we read about King Darius, the Mede (or Kurd) who decreed that all in his land would worship the God of Daniel.

Many Kurds were once Jews and later became Christians.

Many Kurds were present on the Day of Pentecost when Peter first preached the Gospel. Many believed, and Christianity grew and flourished in the land.

Tragically, the sword of Islam swept through Kurdistan centuries later and rules to this day. Today's Kurds remain one of the largest groups of people who have never heard the Gospel.

SERVANT GROUP INTERNATIONAL

PHOTOGRAPHED BACKGROUNDS

Client *Servant Group International*
Design *Anderson Thomas Design Inc.*
Art Director *Jade Novak*
Designer *Jade Novak*
Photographer *David Bailey*

For a neutral background without the headaches, try photography. At first glance, this background looks like a flat tint, but it's really a professionally shot photo. Readers perceive this subliminally and, thus, forgive minor variations in inking.

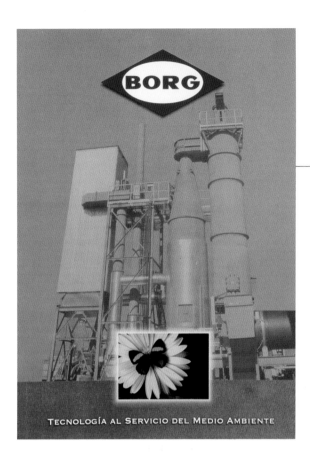

TOUGH SCREENS

Client *Borg Austral S.A.*
Design *GN diseño gráfico*
Art Director *Guillermo Novelli*
Designer *Guillermo Novelli*
Photographer *Guillermo Novelli*
Copywriter *Graciela Radice (from Borg Austral)*

Here's what can happen if you exceed the limits of the equipment. Taken by themselves, these two layouts have reproduced well, considering the challenges of four-color process subjects (especially those with four-color grays) laid out with multiple screen tints of red and teal. But compare the colors on the cover of this piece with those on the inside spread. The daisy in the spread needs less cyan to match the one on the cover, while the teal bar on the cover could use more cyan. The colors do not match because in-line problems restricted flexibility.

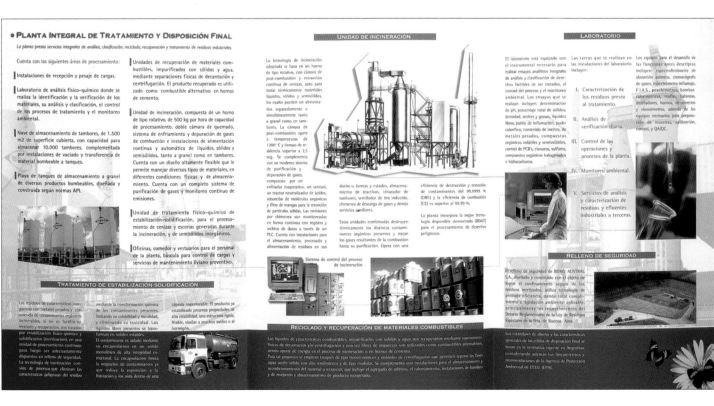

SCREEN SOLUTION

Client	Polygram Italia
Design	Punto e Virgola S.A.S.
Art Director	Anna Palandra
Designer	Anna Palandra
Copywriter	Andrea Tinti

One solution to the problem of matching screen tints across crossovers is shown by the design on this two-page spread. The screen tints have been vignetted from light to dark and separated onto single one-page layouts. The reader gets the effect of a background tint, while the designer gets great flexibility on press.

Targeting Success...

Education Services Foundation

Targeted Vision...

The founders of Education Services Foundation (ESF) envisioned the establishment of a public/private partnership devoted to maximizing access to higher education for students. That vision has been realized with the purchase of student loans from lending institutions, allowing those lenders [to u]se the proceeds to make even more [loans] available.

[In our] role as a secondary market for [student l]oans—working closely with [colleges,] schools, and lenders—we [saw many] other areas in which we could [contribute] to the success of students in [this ar]ena. We responded by [creating prog]rams that help students [borrow wisely a]nd repay responsibly, [educate them] on financial aid [issues, an]d streamline the [process for our] lending institutions.

[The services ES]F have multiplied [for one clear] reason we [value above all else]: We want [to help more students attain a] higher [education.]

ESF Services

Secondary Market
a program for purchasing student loans from lenders, increasing loan availability

Loan Consolidation
a loan program that offers students an opportunity to consolidate multiple student loan debt which can result in a single—often lower—monthly payment

Beyond Due Diligence Counseling Program
a comprehensive counseling service aimed at reducing default rates on student loans

Financial Aid Hotline
a free information service for students and parents with up-to-the-minute student financial aid information and connections for school-specific matters
800-362-1304 or 981-1075 in Jackson, MS

H.E.L.P. Software
a personal student loan planning program provided without charge to colleges, high schools, lenders, and students

Internet Website
an online Internet resource for general higher education and career planning, financial aid advice, and financial planning assistance, with connections for scholarship searches, electronic completion of aid application forms, and H.E.L.P. software
www.esfweb.com

Entrance/Exit Loan Counseling
a service provided by ESF prior to the borrower's receiving the loan proceeds or prior to the borrower's graduating from school

College Access Planning Program
a comprehensive education planning program providing a range of information and counseling to students and their families in the areas of personal assessment, career possibilities, school selection, and wise financing

OneLink
a coordinated electronic funds transfer network through which schools receive disbursements from multiple ESF lenders in one transaction

SCREENED-BACK ILLUSTRATIONS

Client Education Services Foundation
Design Communication Arts Company
Art Director Hilda Stauss Owen
Designer Anne-Marie Otvos Cain
Illustrator Russell Thurston, Artville
Copywriter David Adcock

Another solution to the problem of screen tints is to print a screened-back illustration or photo in the background. Instead of a flat screen, readers see a subtle pattern that breaks up the colors and masks minor color variations. When screening back four-color separations, make sure that the deepest shadows are no more than 20 percent. Anything darker will make the type hard to read.

IN-LINE CONFLICTS

Client Point Park College
Design Stamats Communications, Inc.
Art Director Theresa Black
Designer Theresa Black
Photographer Jason Jones

Even the best original can be spoiled on press by conflicts with other parts of the layout. That's because in offset printing, the plates pick up ink once per revolution. They lay it down on the paper as the paper is pulled through the press. Subjects in line with each other are all affected by the amount of ink on the rollers. If one subject in line needs more magenta but another needs less, a conflict develops that cannot be resolved on press. Such problems can only be avoided in prepress. The best layout is one in which no four-color subject is in line with another. If this is impossible, then the next best layout is one in which one subject can be sacrificed for another, or in which all subjects in line have the same color needs. In this layout, the four-color subjects are designed in line with two-color subjects whose color is not as important.

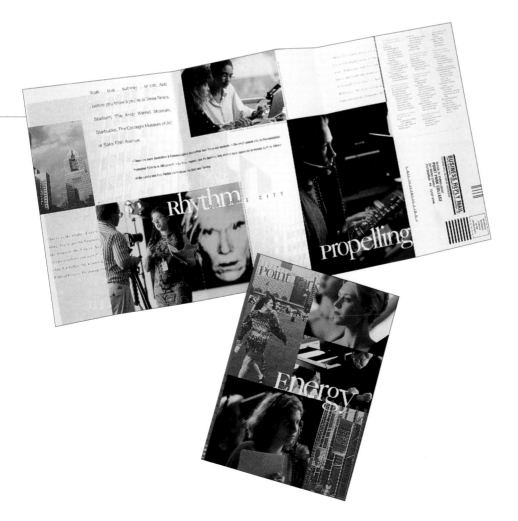

COMPROMISES ON PRESS

Client	*Rider University*
Design	*Stamats Communications, Inc.*
Art Director	*Theresa Black*
Designer	*Theresa Black*
Photographers	*Jason Jones, Steve Jordan*

This layout is a little more problematic. Note that on the left-hand page, the photo on the bottom right needs quite a bit of red, but the photo on the bottom left needs less. The photo that runs across the top of these two conflicting photos is going to suffer.

COLOR-BALANCING IN-LINE PHOTOS

Client	*Follow Me, Sprachaufenhalte, Bern*
Design	*revoLUZion*
Designer	*Bernd Luz*
Copywriter	*Eveline Feier*

In-line photos that have been color-balanced with each other are easy to print, despite the limits of offset plates. Look at the color needs of the photos in this layout. They all require quite a bit of yellow and cyan, as well as a fair amount of magenta. Because the color needs of the photos are the same, the printer should have no trouble achieving good matches for each picture.

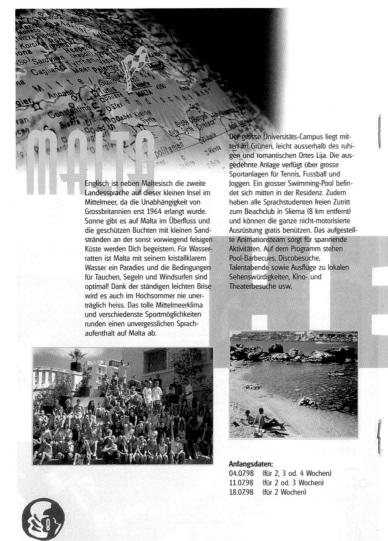

MALTA

Englisch ist neben Maltesisch die zweite Landessprache auf dieser kleinen Insel im Mittelmeer, da die Unabhängigkeit von Grossbritannien erst 1964 erlangt wurde. Sonne gibt es auf Malta im Überfluss und die geschützen Buchten mit kleinen Sandstränden an der sonst vorwiegend felsigen Küste werden Dich begeistern. Für Wasserratten ist Malta mit seinem kristallklarem Wasser ein Paradies und die Bedingungen für Tauchen, Segeln und Windsurfen sind optimal! Dank der ständigen leichten Brise wird es auch im Hochsommer nie unerträglich heiss. Das tolle Mittelmeerklima und verschiedenste Sportmöglichkeiten runden einen unvergesslichen Sprachaufenthalt auf Malta ab.

Der grosse Universitäts-Campus liegt mitten im Grünen, leicht ausserhalb des ruhigen und romantischen Ortes Lija. Die ausgedehnte Anlage verfügt über grosse Sportanlagen für Tennis, Fussball und Joggen. Ein grosser Swimming-Pool befindet sich mitten in der Residenz. Zudem haben alle Sprachstudenten freien Zutritt zum Beachclub in Sliema (8 km entfernt) und können die ganze nicht-motorisierte Ausrüstung gratis benützen. Das aufgestellte Animationsteam sorgt für spannende Aktivitäten. Auf dem Programm stehen Pool-Barbecues, Discobesuche, Talentabende sowie Ausflüge zu lokalen Sehenswürdigkeiten, Kino- und Theaterbesuche usw.

Anfangsdaten:
04.07.98 (für 2, 3 od. 4 Wochen)
11.07.98 (für 2 od. 3 Wochen)
18.07.98 (für 2 Wochen)

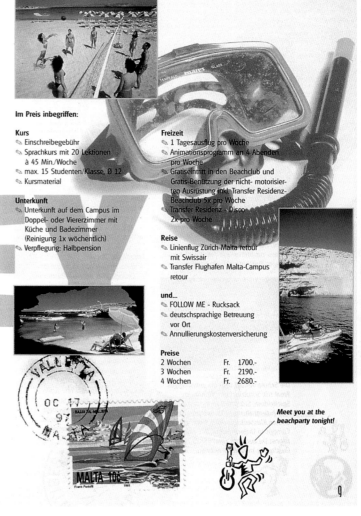

Im Preis inbegriffen:

Kurs
- Einschreibegebühr
- Sprachkurs mit 20 Lektionen à 45 Min./Woche
- max. 15 Studenten/Klasse, Ø 12
- Kursmaterial

Unterkunft
- Unterkunft auf dem Campus im Doppel- oder Viererzimmer mit Küche und Badezimmer (Reinigung 1x wöchentlich)
- Verpflegung: Halbpension

Freizeit
- 1 Tagesausflug pro Woche
- Animationsprogramm an 4 Abenden pro Woche
- Gratiseintritt in den Beachclub und Gratis-Benützung der nicht- motorisierten Ausrüstung inkl. Transfer Residenz- Beachclub 5x pro Woche
- Transfer Residenz - Disco 2x pro Woche

Reise
- Linienflug Zürich-Malta retour mit Swissair
- Transfer Flughafen Malta-Campus retour

und...
- FOLLOW ME - Rucksack
- deutschsprachige Betreuung vor Ort
- Annullierungskostenversicherung

Preise
2 Wochen Fr. 1700.-
3 Wochen Fr. 2190.-
4 Wochen Fr. 2680.-

Meet you at the beachparty tonight!

UNBALANCED COLOR

Client	*Rana magazine (self-promotion)*
Design	*frogdesign inc.*
Arbiter	*Hartmut Esslinger*
Creative Directors	*Steven Skov Holt, Gregory Hom*
Art Director	*Gregory Hom*
Editorial Director	*Steven Skov Holt*
Senior Designers	*Matthew Clark, Eddie Serapio*
Designer	*Thomas Preston Duval*
Guest Editor	*Phil Patton*
Photographers	*Hashi, Dieter Henneka, Steve Moeder, Sysop Craig Syverson*

The photos in this layout have not been color-balanced as well. If you look closely, you will see photos with heavy red (magenta and yellow) requirements in line with photos that have light red requirements. The layout works because the point of the design is to present a mosaic of bright colors, so individual color balance is not an issue.

SAME INK REQUIREMENTS

Client	*Food Group*
Design	*Mires Design Inc.*
Art Director	*Scott Mires*
Designers	*Scott Mires, Deborah Hom*

Here is another example of well-balanced photos. All of the photos have the same ink requirements, except for the photo of the wave in the right-hand row. Its ink needs are so light (especially magenta) that it should not present a problem on press.

SACRIFICING ONE PHOTO FOR ANOTHER

Client | CJH Development Corporation
Design | The Creative Response Company, Inc.
Art Director | Arne Sarmiento
Designer | Arne Sarmiento
Photographer | Francis Abraham
Copywriter | Pia Gutierrez

Here, the individual photos are important in the design. Generally, the layout works well because most of the photos are not in line with each other. The background could be a problem, but because it is a line drawing and not a solid tint, minor variations in color would not be noticed. There is a conflict with the two photos in line on the right-hand page, however. The conflict has been solved by compromising the needs of the bottom photo, which is too red.

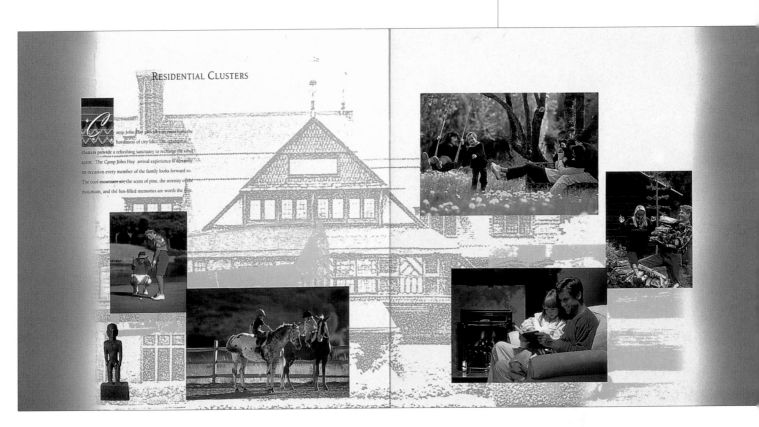

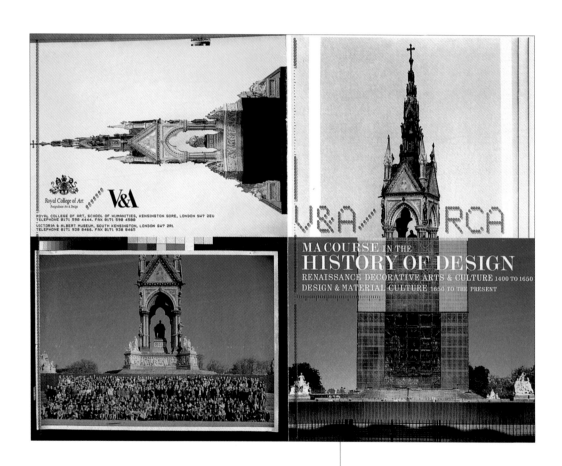

GHOSTING

Client	*Royal College of Art/Victoria & Albert Museum*
Design	*Graphic Thought Facility*
Creative Directors	*Paul Neale, Andrew Stevens*
Art Directors	*Paul Neale, Andrew Stevens*

Another in-line problem to beware of is ghosting.
Ghosting occurs when one subject on a page strips ink
away from another in-line subject. The first subject
starves the one below it, making it impossible to print
the second subject with bright colors. If you look very
closely at the sky on the right side of the crowd shot
(lower left page), you can see a faint ghost where the
black shadow of the monument above has stripped
away the ink.

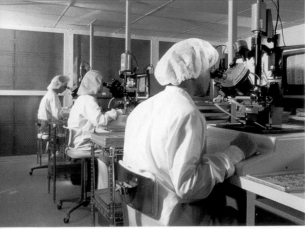

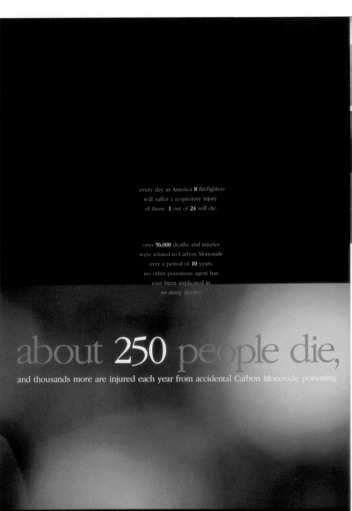

every day in America **8** firefighters
will suffer a respiratory injury.
of those, **1** out of **24** will die.

over **56,000** deaths and injuries
were related to Carbon Monoxide
over a period of **10** years.
no other poisonous agent has
ever been implicated in
so many deaths.

about 250 people die,

and thousands more are injured each year from accidental Carbon Monoxide poisoning.

On a Tuesday, in one of our plants that is environmentally controlled, with stringent, comprehensive Electrostatic Discharge (ESD) systems in place, where Die Attachment, Calibration, Wire Bonding and highly sensitive, proprietary operations are performed in a class 1000 clean room - hazardous gas detection equipment is manufactured by hand specifically for, among others, the challenging tasks of today's Firefighter.

At the same time dashing from a hazardous response truck, a Firefighter responds to the urgent need to assess the threat of a grimy railcar-derailment, spilling Chlorine gas, or perhaps to a lethal domestic Carbon Monoxide leak from a household furnace some half a hemisphere away. In an instant, two worlds meet over a gas-safety device which in either case will serve to protect and save human life - an AIM Safety gas detector.

AIM Safety gas detection products have always brought people and safety together. The relationships we've formed over gas safety are significant and deep. Friendships with our nations fire departments... with industrial corporations, utilities and select marketing partners... with our customers and within communities - these are the relationships that help define us as a company, set us apart, and are responsible for our growth and success.

AVOIDING GHOSTS IN LAYOUTS

Client	*Aim Safety Company, Inc.*
Design	*Big Eye Creative, Inc.*
Art Director	*Perry Chua*
Designer	*Perry Chua*
Illustrator	*Stephen Dittberner*
Photographers	*Grant Waddell, Dann Ilicic*
Copywriter	*Craig Holm*

You cannot correct a ghost on press, but you can design layouts that avoid causing them. Here, for example, the heavy black tint has stripped away a lot of ink from the four-color subject in line with it, but we see no ghost. The reason is that the tint aligns flush with the separation, so ink is stripped evenly.

ALIGNING ART AND TINTS PROPERLY

Client	*Learjet*
Design	*Greteman Group*
Art Directors	*Sonia Greteman, James Strange*
Designers	*Sonia Greteman, James Strange*
Copywriter	*Nita Scrivner*

Here, too, the layout avoids ghosts by aligning art and tints so that ink strips evenly from the subjects. Ghosts do not occur on the far left page because the dark photo carries the same weight of ink as the surrounding background. The tint below the light photo might have shown a darker ghost where the ink has not been stripped evenly, except that the tint is so dark we can't see a difference. Predicting ghosts is extremely difficult. If you have a question about whether you're going to produce one, consult your printer ahead of time.

COLOGNE

Wear your own signature statement with these revitalizing colognes. Uniquely formulated with aloe vera, jojoba oil and essential oils, they refresh the skin while adding a layer of fragrance to complement your lifestyle.

75 ML · 2.5 FL OZ
02321 EUCALYPTUS
02322 LAVENDER
02323 VETIVER

FOAMING BATH

Surround yourself with pure herbal fragrances while mounds of bubbles delight your senses. Enriched with jojoba oil, aloe vera and Vitamin E, the copious foam creates a private sanctuary that leaves your skin feeling soft and renewed.

235 ML · 8 FL OZ
02071 EUCALYPTUS
02072 LAVENDER
02073 VETIVER

GLYCERINE SOAP

Pure vegetable glycerine and fragrant essential extracts are the beginning of these beautifully scented jeweltone bars. Enriched with jojoba oil, honey and Vitamins A and E, the gentle lather cleanses thoroughly and then rinses away clean. Perfect for all skin types.

2 SOAPS · 85 G / 3 OZ EACH
02091 EUCALYPTUS
02092 LAVENDER
02093 VETIVER

LIGHT INK COVERAGE

Client	The Thymes Limited
Design	Design Guys
Art Directors	Steven Sikora, Lynette Sikora, Gary Patch
Designers	Jay Theige, Amy Kirkpatrick
Photographer	Patrick Fox
Copywriter	Jana Branch

Similarly, if four-color subjects use only a little ink, as on the left page here, you won't get a ghosting problem. You also won't get a ghost if the in-line subject is busy and lacks broad, flat areas of color.

DIGITAL PRINTING

Client	Lamplight Colour, Ltd.
Design	Carl Dominic James Ison
Photographer	Phil Taylor (Lamplight Colour, Ltd.)

To avoid in-line conflicts and ghosting completely, consider using a different process altogether. This job was printed on a Xeicon digital printing press, a kind of glorified laser printer. Since digital presses use no ink fountains, no ink is stripped away from one area by another. Color balancing is trivial – if your designs look good on your monitor, they'll look good on paper. The down side? The process is completely digitized, so each page is created anew as it prints. Thus, digital printing is slow and can be very expensive. Use it only for short-run jobs that would cost the earth to print any other way.

WINDOWS

APPROPRIATE DIGITAL DESIGN

Client | *Tracy Griffin Sleeter*
Design | *Tracy Griffin Sleeter*
Designer | *Tracy Griffin Sleeter*
Illustrator | *Tracy Griffin Sleeter*

Digital printing also looks a bit hard-edged, which is no surprise. The dots that a digital press "prints" never gain a jot. They retain their shape just as they are generated in your computer. Traditional ink presses, in contrast, do experience dot gain as the ink spreads into the paper fibers, softening the hard edges of the dots. For a job like this one, where the look is vibrant and modern, digital printing is perfect.

TYPE ON PHOTOS

Client | *Elbow Beach Bermuda, a Rafael Resort*
Design | *Turkel Schwartz & Partners*

A picture is worth a thousand words, says the old saw, but in my opinion, there's nothing like type to convey a message. For design purposes, one of the biggest technical questions about type is: when should you overprint type, and when should you reverse it? A good rule of thumb is the Rule of 30: don't overprint type on anything darker than a 30 percent screen; don't reverse out type on anything less than a 30 percent screen. The Rule of 30 can be flexed somewhat, but not much. Look carefully at these examples. The designer has placed both overprinted and reversed-out type extremely well. But notice the type over the man's hand in the bottom right, where the halftone screen fades to less than 30 percent. Also note the overprinted type in the woman's ear on top right.

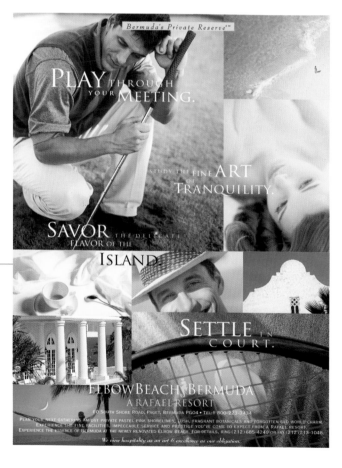

IN JERMYN STREET ON THE THOROUGHFARE BEHIND THE FAÇADE THE GEOMETRY OF ASYMMETRY HAS DEFINED A NEW BUILDING: PRINCES HOUSE. THE FLUID COMPLEXITY OF THE REBUILT SPACE IS ECHOED IN THE SUBTLE MESHING OF TEXTURES, COLOURS AND MATERIALS. THE BUILDING IS RICH IN DETAIL, THE PLACE IS FULL OF HISTORY.

REVERSED-OUT TYPE

Client	Ivory Gate, Ltd.
Design	Cartlidge Levene
Art Director	Ian Cartlidge
Designers	Emma Webb, Tim Beard, Ben Tibbs
Photographer	Richard Learoyd
Technical Illustrator	John Hewitt
Copywriter	Michael Horsham

When placing reversed-out type, select a photo where you don't get a lot of bounce between dark and light halftones. If you must reverse type out of such a background, then specify a larger point size in a sans serif or bold typeface. Never reverse out serif type smaller than 10-point or sans serif type smaller than 8-point. And forget about reversing out italic – italic type is tough enough to read as it is.

COLORED TYPE

Client	*Giovanna Sonnino and Planita*
Design	*Teikna*
Art Director	*Claudia Neri*
Designer	*Claudia Neri*
Copywriter	*Giovanna Sonnino*

Adding color to type does not change the Rule of 30.
In fact, specifying colored type that is on the opposite
side of the color wheel from the background (here, red
type over blue background) adds to the bounce our
eyes see because such colors add more contrast.

第三十四届国际家俱展览会瓦伦西亚

会瓦伦西亚

届国际家俱展览

第三十四

流行式，表面粗糙型和細林匾柃的秩序直設計布置，當然還包括古典的 Boulevard 林陰路式和 Gallery 書廊式

的家具精選；第七展廳將為您展示更加豪華的古典和田園風格的佳作；最后一個展廳名為先鋒者展廳，再一次

和 SIDI 國際室內裝璜設計沙龍聯合，為您斯露當今家具設計佼佼者的集翠。

短短的六天，一年僅一次。瓦倫西亞將熱誠地歡迎您光顧這一家具大世界。

每年一度

時間為六天，來訪者達五萬以上，一千多個參贊公司分別來自歐洲，亞洲和美洲。就在這里，FIM西班牙‧瓦倫西亞國際家具展覽會將為您展示，當今世界家具的新動態，新產品；為您提供難尋的良機。

每年只有一次，而每次只持續六天。盡管如此，如果您是一位具有簽賞能力的商人，這六天時間將是無法估量的，它很可能使您在整年之余坐享其成。就在同一地點，您可以飽覽一個壯觀的當今家具世界，可以獲得一個完整的商業視野，您所期望的各種貿易良機隨時有機會出現。

第三十四屆瓦倫西亞國際家具展覽會，于一九九七年九月二十二日至九月二十七日在西班牙，瓦倫西亞市舉行，有一百多個國家和地區前來參加。巨大的展覽館其總面積為180,000平方米將容納世界家具市場應有盡有的產品，五萬名來自世界各地的商人可以欣賞到歐洲，亞洲和美洲的上千家家具制造廠的杰作。

您將在觀賞優雅的古典式家具的同時，發現為未來二十一世紀開創的新產品：鋁制座椅，精制皮革的三套

TYPE SOLUTIONS

Client	*Montreal Segurança*
Design	*AWG Graphics Communicacão, Ltda.*
Art Director	*Renata Claudia de Cristofaro*
Designer	*Luciana Vieira*
Photographer	*Fabio Rubinato*

If you must place type over photos with a lot of dark/light contrast, you can try several tricks. One example is to screen back the photos so the darkest shadows are no deeper than 20 or 30 percent, then overprint the type. Or use outlines to define type.

SHADOWED TYPE

Client	*Henderson High School*
Design	*WorldSTAR Design*
Art Director	*Greg Guhl*
Designer	*Greg Guhl*

Shadowing the type can also work extremely well. Try to imagine what the type would have looked like on the posterized photo at top left if it hadn't been shadowed.

Rassige Rhythmen im besten Raumklang durch das eingebaute Boxensystem.
Hot rhythms in the best acoustics through the built-in speaker system.

Licht lockt Leute – und steigert die einzigartige Erlebnis-Atmosphäre.
Light attracts people and stimulates the exceptional, exciting atmosphere.

Der in der Schirmspitze eingebaute Windmesser schließt nach Erfordernissen des Standortes automatisch den Schirm.
The built-in windmeter at the top of the umbrella closes the umbrella automatically when necessary.

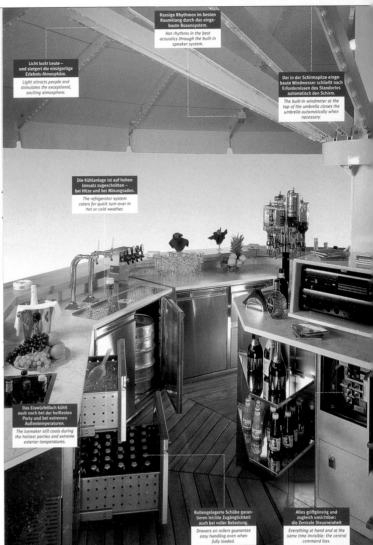

Die Kühlanlage ist auf hohen Umsatz zugeschnitten – bei Hitze und bei Minusgraden.
The refrigerator system caters for quick turn-over in hot or cold weather.

Das Eiswürfelfach kühlt auch noch bei der heißesten Party und bei extremen Außentemperaturen.
The icemaker still cools during the hottest parties and extreme exterior temperatures.

Rollengelagerte Schübe garantieren leichte Zugänglichkeit auch bei voller Belastung.
Drawers on rollers guarantee easy handling even when fully loaded.

Alles griffgünstig und zugleich unsichtbar: die Zentrale Steuereinheit.
Everything at hand and at the same time invisible: the central command box.

Spitzentechnik für Spitzenrendite

■ Meissl bietet die besten Voraussetzungen fürs perfekte Event-Marketing. Kein Wunder, daß erfolgreiche Gastronomen, Hoteliers und Brauereien auf Meissl setzen.

Alle Meissl Schirmbars sind auf höchste Belastung ausgelegt. Nicht nur was Wind und Wetter betrifft, auch die Bar ist auf Höchstleistung vorbereitet: Stabile, erprobte Konstruktionen, widerstandsfähige Materialien, klare Linien und hochwertige technische Gastro-Ausstattung. Denn schließlich soll Ihr Geschäft brummen und nicht die Gäste!

Top Technology for Top Returns

Meissl offers the best conditions for perfect event-marketing. No wonder that successful innkeepers, hoteliers and breweries rely on Meissl.

All Meissl Umbrella Bars meet the highest standards. Not only wind and weather proof, the bar also offers top performance: stable, tested construction, resistant materials, clear lines and high tech gastronomic equipment. As in the end – it is your business that should move and not your guests.

Das passende Zubehör wird mitgeliefert: Hocker und Stehtische setzen die markante Linie fort – und sind ebenso stabil wie die Konstruktion der Schirmbar selbst!

The matching accessories are delivered with the bar: stools and bar tables extend the product line – and are as stable as the construction of the Umbrella Bar itself.

Das **komplette** Schirmbarkonzept

MEISSL

BOXED TYPE

Client	*Schlosserei J. Meissl GmbH*
Design	*Modelhart Grafik-Design DA*
Art Director	*Herbert O. Modelhart*
Illustrator	*Herbert O. Modelhart*
Designers	*Herbert O. Modelhart, Kristina Düllmann*
Photographer	*Walter Oczlon*
Copywriter	*Herbert Lechner*

You can also put the type in a box of either white or dense color, then overprint or reverse out at will.

CROPPING TYPE

Client	*Eaglequest Golf Centers*
Design	*Karacters Design Group*
Creative Director	*Maria Kennedy*
Designers	*Pam Winrow, Maria Kennedy*
Photographer	*Robert Walker*

When you've tried every design trick you know and you still can't avoid placing type in an illegible position, try to place it so only the bottoms of the letters are cut off. In our alphabet, letter tops carry more identification information than letter bottoms. Look at the type in the photo on the upper left. Even though we can't really see the bottoms of the "e" and "a" in "Learn," we have no trouble reading the word. Compare with the "c" and "t" in the word "Practice."

Learn. Practice. Play.

Learn. Practice. Play.

Neil
Mainte

Pacific G
8080 Cen
Tumwater
Washington
98501
Telephone:
(360) 786-86
Facsimile:
(360) 786-862
www.eaglequest

eaglequ
GOLF CE

Practice. Play.

5419 Del Roy Drive

Dallas

Texas

75229

Direct Line:

(214) 706-6925

Facsimile:

(214) 706-6924

www.eaglequestgolf.com

eaglequest

Learn. Practice. Play.

LIMITED REVERSES

Client *TypoGraphic, issue 51, produced by International Society of Typographic Designers*

Design *Cartlidge Levene*

Art Director *Ian Cartlidge*

Designers *Ian Styles, Hugh Tarpey, Emma Webb, Phil Costin*

Photographer *Richard Learoyd*

Limit the use of reversed-out type to small blocks of copy. People aren't used to reading reversed-out type, so they must slow down to process it. In addition, people's eyes bounce around when reading such type, due to the contrast between the dark background in all the letters' negative space, and the white letters themselves. We see a halo effect around each letter, which is fatiguing to read. If you must reverse out large blocks of copy, then choose your audience carefully – you are asking them for a lot of patience. In this case, the audience was type designers, not readers.

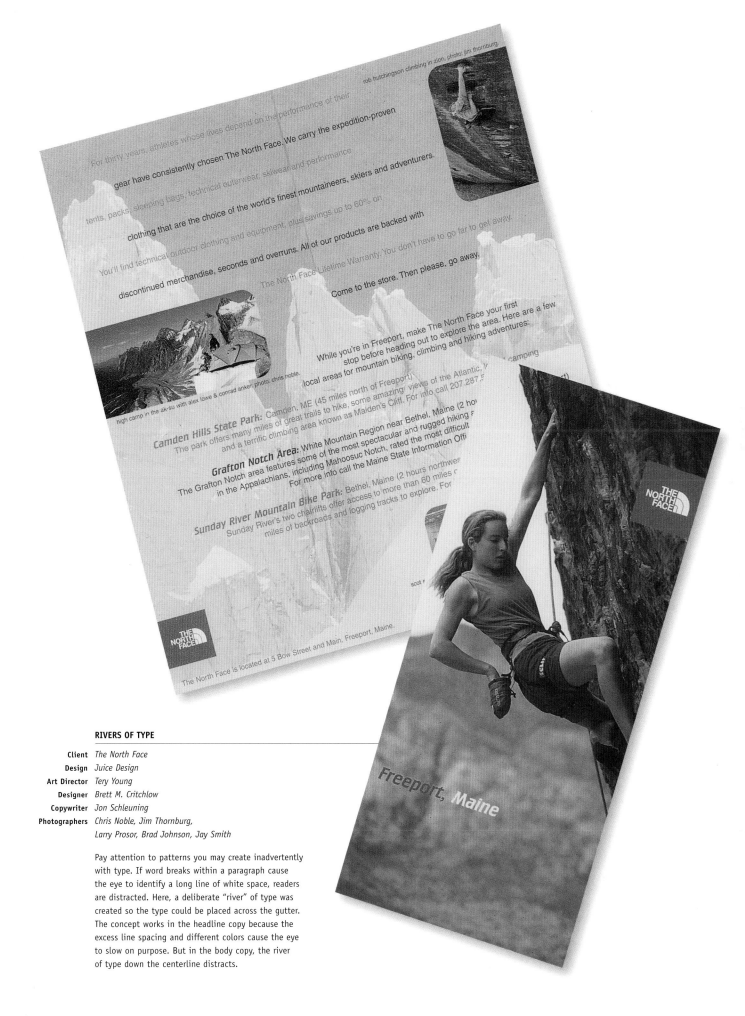

RIVERS OF TYPE

Client *The North Face*
Design *Juice Design*
Art Director *Tery Young*
Designer *Brett M. Critchlow*
Copywriter *Jon Schleuning*
Photographers *Chris Noble, Jim Thornburg,*
Larry Prosor, Brad Johnson, Jay Smith

Pay attention to patterns you may create inadvertently
with type. If word breaks within a paragraph cause
the eye to identify a long line of white space, readers
are distracted. Here, a deliberate "river" of type was
created so the type could be placed across the gutter.
The concept works in the headline copy because the
excess line spacing and different colors cause the eye
to slow on purpose. But in the body copy, the river
of type down the centerline distracts.

CROSSOVER TYPE

Client	*Broadgate Club West*
Design	*Studio Myerscough*
Original Conceptualists	*Morag Myerscough, Eugenie Biddle, Joe Kerr*
Designers	*Morag Myerscough, Chris Merrick*
Computer Imager	*Sham*
Architectural Text Copywriter	*Joe Kerr*

Placing type across the gutter can be extremely risky. Even in the best of circumstances, folding and trimming are not very accurate, due to variables such as page count, paper caliper, binding method, and equipment limitations. Why pay strict attention to letter kerning and word spacing, and then throw your fate into the maw of a folding machine that is accurate only to within 1/16 inch? Or less? Having said that, here are some tricks you can use to make type align across the gutter: Never place letters in the center cutoff. But if you do, at least choose a very large point size and blocky typeface.

I LOVE THE REST OF MY LIFE THOUGH IT IS TRANSITORY LIKE A LIGHT AZURE MORNING GLORY.

Fierce competition in financial services has sparked a surge of design-conscious brand building. So will Britain buy into b2 beach culture and gentle Goldfish?

Colour of

MONEY

When well-informed, well-educated people find the products you sell at best confusing and at worst utterly unintelligible, you are an industry with a problem. When leading companies in your sector are repeatedly fined for seriously misleading vulnerable customers in order to make a quick buck, you are an industry which may be facing a crisis.

Both criticisms could justifiably be levelled at Britain's financial services industry yet it seems to have been very slow at recognising the extent and depth of the public's distrust of the products it sells and – none significantly – of the organisations which sell them. If it wasn't for the fact that we all need pensions, insurance, credit cards and bank accounts, they might have put their house in order long ago.

That traditional providers of financial services had little understanding of the way in which they are perceived by much of the public can be judged from their reaction to new entrants to their market. In 1995, when Virgin started offering financial services, traditional providers were scathing. Always something of a maverick, Virgin was easy to dismiss as a serious

competitor. Tellingly, however, many of the criticisms levelled at it missed the point: their major criticism of Virgin was that it was not an established financial services company. However, with financial services companies so poorly regarded this was surely its biggest selling point. Certainly, the 250,000 people who have since invested £1.5 billion seem not to have seen this as a deterrent.

Virgin's other strength, the fact that people trusted the brand, was not really taken seriously. To judge from comments made by established financial services companies at that time, 'brands' were seen as dubious concepts that flaky marketing people concerned themselves with, and not seen to be an important issue for sober suited financial services experts. After all, who needs the simple

reassurance of a brand name, when you can now your customer with sexy terms such as 'non-protected rights policy', 'accumulation units', and 'APR'? The Abbey National's condescending reaction to the launch of Virgin Direct was typically snooty: '...some people will be attracted by the gimmicks and the Virgin brand name...'

But now, with everyone from Sainsbury's to General Motors successfully entering the financial services market, it is becoming clear that the increasingly sophisticated methodology of brand building is going to shake up the financial services industry whether it likes it or not. And,

GRUNGE TYPE

Client	*Design, produced by Design Council*
Design	*Alexander Boxill Visual Communication*
Art Directors	*Jayne Alexander, Violetta Boxill*
Designers	*Jayne Alexander, Violetta Boxill*

Another type trick is to choose a typeface that doesn't have an obvious kerning pattern. Crossover discrepancies will be masked from the reader's eye.

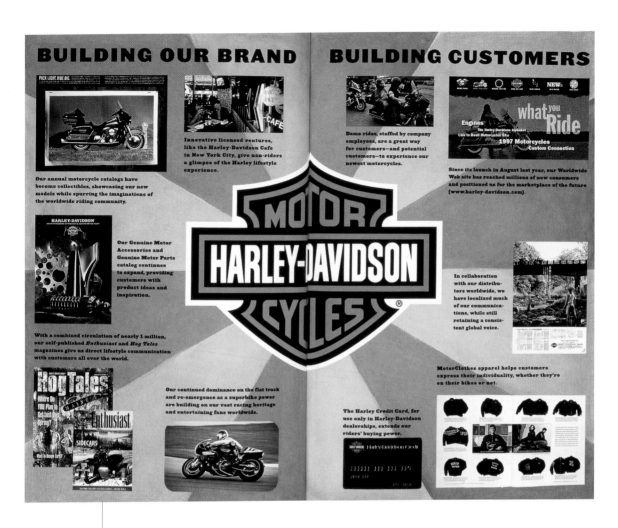

MINIMIZING TYPE LOSS IN FOLDS

Client *Harley-Davidson, Inc.*
Design *VSA Partners*
Designers *Curt Schreiber, Ken Fox, Fletcher Martin*
Copywriter *Ken Schmidt*

If you're designing with crossovers on jobs that are saddle-stitched, place type in the center spread if possible. If the center spread is impossible, place type on a two-page spread that is as close to the center spread as possible. This will minimize the amount of paper lost in the fold, which can be considerable, as this layout demonstrates. If the job is perfect bound, place type in a signature as near to the outside cover as you can. This allows readers to open the pages more fully and read type closer to the bound edges.

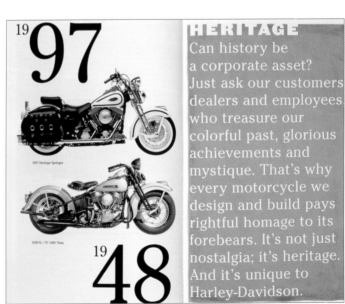

CREATIVE TYPE USE

Client	*Centris*
Design	*Widmeyer Design*
Art Directors	*Ken Widmeyer, Dale Hart*
Designer	*Dale Hart*
Illustrator	*Tony Secolo*
Photographer	*Donna Day*
Copywriter	*Ken Widmeyer*

Break up the copy on purpose so the center line
looks like a natural break. Here, the designer has used
a different point size and letter weight to make the
center break into a deliberate design element.

COLOR BREAKS

Client	*Eden Communications: Pfizer, Inc.*
Design	*Malik Design*
Art Director	*Donna Malik*
Designer	*Donna Malik*
Illustrator	*Jeff Cornell*
Copywriter	*Polly Edelson*

Pay attention to crossover breaks in artwork. Here, the designer has broken the row of faces between two heads, which is great. But the color break is not as good. Instead of a continuous spectrum from red to blue, we get a bit too abrupt a step. Such color breaks do not look obvious in prepress. It's only when we get on press and try to match crossovers that the problem can loom large. When you're placing crossover photos, try running a hairline tape over your color monitor down the centerline of the spread and see if the crossover break comes at a good place.

THUNDERSTONE?

Thunderstone is an independent R&D company that provides high-end software to manage, retrieve, filter and electronically publish information content consisting of text and multimedia. Over the last 17 years Thunderstone has sold more than 400,000 end-user licenses to corporations, software developers, content providers and government entities. Privately held, Thunderstone maintains a constant commitment to excellence and innovation within diverse areas of information management and retrieval. Its focus on constant technical advancement provides its customers with the ability to specifically address the demands of their user base without compromise.

THE THUNDERSTONE DIFFERENCE

Large organizations generally have specific information retrieval and management needs that can only be met by a combination of several unrelated products, but this type of integration is time consuming and error prone. Other retrieval vendors just index text and provide the ubiquitous list of answers. Thunderstone will realize and implement the entirety of the application exactly as envisioned; rapidly and maintainably. Our Texis RDBMS is fully capable of managing text and multimedia objects out of the box without the need to resort to loosely coupled "Data-Blade" programs. The Thunderstone infrastructure can meet the diverse and unique needs for almost any internet application.

The marketplace for internetworked information management/retrieval systems is rapidly expanding. Texis represents a crucial part of the information requirement by symmetrically merging objects, relational data, and full text retrieval. Thunderstone has been a pioneer since 1984 with the first concept based retrieval product on the market. No other product can make this claim, and no integration of other products can easily replicate Texis' functionality.

www.thunderstone.com
[S E A R C H C L A S S I F Y D I S S E M I N A T E]

INK ON PAPER

Client	*Thunderstone*
Design	*Zylstra Design and Denise Kemper Design (collaboration)*
Art Directors	*Melinda Zylstra, Denise Kemper*
Designers	*Melinda Zylstra, Denise Kemper*
Copywriter	*Thunderstone*

While it might be fun to thrill your artistic soul messing around with outré designs on your desktop, creativity really counts when ink hits the paper. For me as a production manager, the most memorable designs are the ones that pair all the best in paper with all the best in design. Take this piece, for example. "Columns" paper by Neenah is formulated with subtle, alternating stripes of pale and paler white. Look at how these designers used this paper characteristic to enhance their design.

[M A N A G E S E A R C H R E T R I E V E]

information

THUNDERSTONE

VIGNETTES ON UNCOATED PAPER

Client	Bank of China, Hong Kong
Design	Kan & Lau Design Consultants
Art Directors	Kan Tai-Keung, Lau Siu Hong
Designer	Cheung Lai Sheung

Here, the designers have used the rough texture of the paper to make the vignette on the edge look natural, yet subtle.

WORK OF ART

Client	*Tokushu Paper Manufacturing Co. Ltd.*
Design	*Kan & Lau Design Consultants*
Art Director	*Kan Tai-Keung*
Designers	*Kan Tai-Keung, Yu Chi Kong, Leung Wai Yin*
Illustrators	*Kan Tai-Keung, Kwun Tin Yau, Leung Wai Yin, Tam Mo Fai*
Photographer	*C.K. Wong*

Everything works together here - the paper (Bornfree, a rough-finished recycled paper from Tokushu Paper), the art (calligraphy and watercolors reminiscent of ancient China), and the message (philosophical prose derived from Buddhist principles).

"BORNFREE" CONNOTES A FREE AND EASY LIFE-

STYLE THAT IS HARMONIOUS WITH NATURE,

BACKED BY A PHILOSOPHICAL LINKAGE WITH

《自在》乃中國佛家思想中的一種生活哲理：
CHINESE BUDDHISM THINKING. CATERING TO
逍遙自在，無憂無礙，與大自然和諧共處。
THE CHINA MARKET, THE DESIGN OF "BORNFREE"
《自在》花紋紙系列是特別為中國市場面
PAPER SERIES IS DERIVED FROM THE IDEA OF
設計的紙張。意念來自中國傳統手造紙的毛
BAMBOO GRAINED SURFACE AND TEAR-OFF EDGES
邊和竹紋肌理，以自然的變化構成自由的韻
OF TRADITIONAL CHINESE HAND-MADE PAPER.
律，表現中國人悠然自得的生活精神。
THE TEXTURE ENHANCES A NATURAL, BRISK

AND RHYTHMICAL APPEAL WHICH REPRESENTS

A PART OF THE CHINESE CAREFREE LIFESTYLE.

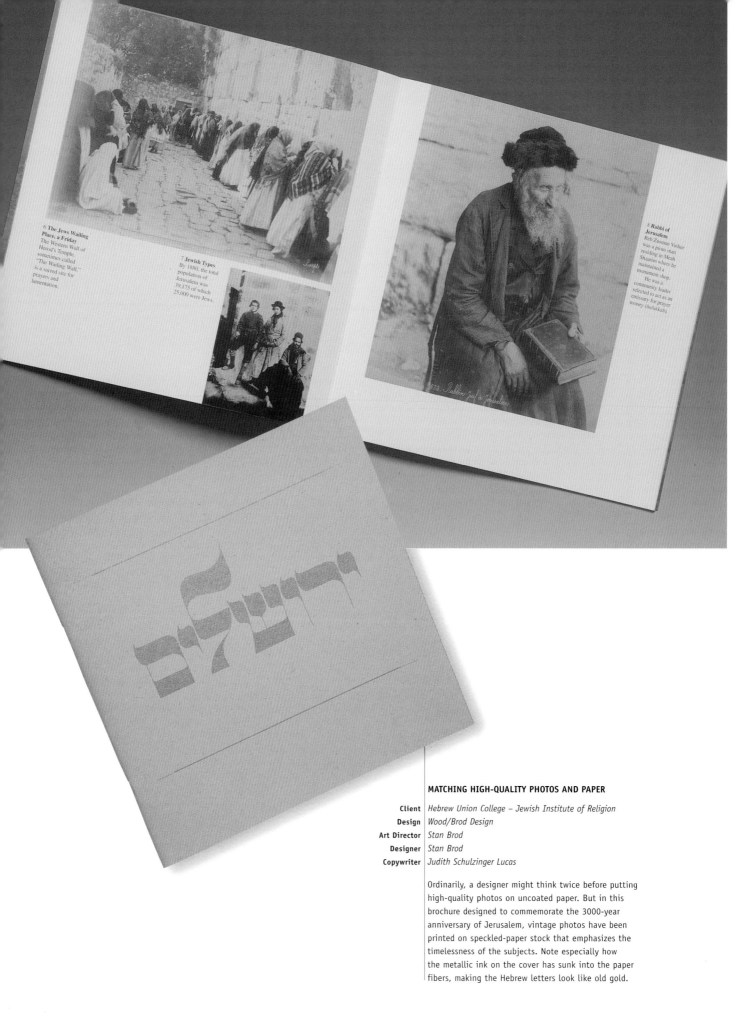

6 **The Jews Wailing Place, a Friday**
The Western Wall of Herod's Temple, sometimes called "The Wailing Wall," is a sacred site for prayers and lamentation.

7 **Jewish Types**
By 1880, the total population of Jerusalem was 39,175 of which 25,000 were Jews.

8 **Rabbi of Jerusalem**
Reb Zosman Vasher was a pious man residing in Meah Shaarim where he maintained a monument shop. He was a community leader selected to act as an emissary for prayer money (halukkah).

MATCHING HIGH-QUALITY PHOTOS AND PAPER

Client	Hebrew Union College – Jewish Institute of Religion
Design	Wood/Brod Design
Art Director	Stan Brod
Designer	Stan Brod
Copywriter	Judith Schulzinger Lucas

Ordinarily, a designer might think twice before putting high-quality photos on uncoated paper. But in this brochure designed to commemorate the 3000-year anniversary of Jerusalem, vintage photos have been printed on speckled-paper stock that emphasizes the timelessness of the subjects. Note especially how the metallic ink on the cover has sunk into the paper fibers, making the Hebrew letters look like old gold.

take another look

Client	_Canson-Talens, Inc._
Design	_Tom Fowler, Inc._
Art Directors	_Thomas G. Fowler, Karl S. Maruyama_
Designers	_Thomas G. Fowler, Karl S. Maruyama, Brien O'Reilly_
Copywriter	_Karl S. Maruyama_

It's all too easy to select an unusual paper stock and print any old design on it, relying on the uniqueness of the paper to carry the day. But look at the imagination used here, where Canson Satin, a translucent paper, has been used to make the model appear to be looking at us through a rain-washed window. The delicate fuzziness of the photo has been preserved during scanning, and the type has also been made to look fuzzy. These prepress techniques add to the overall effect.

COLORED PAPER

Client	*Sealaska Corporation*
Design	*Hornall Anderson Design Works Inc.*
Art Directors	*Jack Anderson, Katha Dalton*
Designers	*Katha Dalton, Heidi Favour, Nicole Bloss, Michael Brugman*
Illustrator	*Sealaska archive*
Copywriter	*Michael E. Dederer*

Northwest coast Indians did not have paper for their art until well into the nineteenth century. Instead, they used wood. Note how the heavily textured paper works with the subjects to create the impression of wood carving. Because the paper stocks chosen were colored, the designers asked the printer for ink drawdowns (ink samples smeared on the paper), so they could make sure that the custom inks specified in their prepress program looked the way they wanted them to on paper.

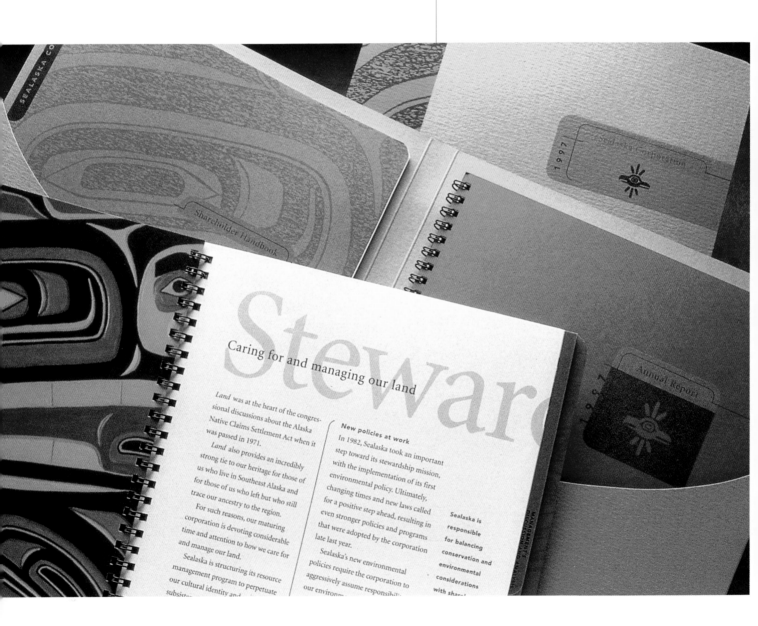

DUCHY
ORIGINALS

OATEN BISCUITS
Stoneground texture. Oven baked taste.

PROOFS

Client	*Prince Charles's Duchy of Cornwall*
Design	*Lewis Moberly*
Design Director	*Mary Lewis*
Designers	*Mary Lewis, Ann Marshall*
Photographer	*David Gill*

And now a word about proofing. The best proofs for color matching are the ones you and the printer find easiest to work with. For many of us old-timers, press proofs printed on the actual paper we plan to run are the best – and also the most expensive. A cheaper alternative that is widely accepted by the printing community is an off-press proof such as Cromalin® or Matchprint®. Digital proofs are also now coming into their own, as printers learn to adjust their eyes and work habits to interpret them accurately. But if color matching is absolutely crucial, nothing works better than the actual product. I have brought along everything from hybrid poinsettias to rolls of French ribbon on press okays for clients who have been especially commanding.

directory